THE FOCAL EASY

PHOTOSHOP
CS2

The Focal Easy Guide Series

Focal Easy Guides are the best choice to get you started with new software, whatever your level. Refreshingly simple, they do not attempt to cover everything, focusing solely on the essentials needed to get immediate results.

Ideal if you need to learn a new software package quickly, the Focal Easy Guides offer an effective, time-saving introduction to the key tools, not hundreds of pages of confusing reference material. The emphasis is on quickly getting to grips with the software in a practical and accessible way to achieve professional results.

Highly illustrated in color, explanations are short and to the point. Written by professionals in a user-friendly style, the guides assume some computer knowledge and an understanding of the general concepts in the area covered, ensuring they aren't patronizing!

Series editor: Rick Young (www.digitalproduction.net)

Director and Founding Member of the UK Final Cut User Group, Apple Solutions Expert and freelance television director/editor, Rick has worked for the BBC, Sky, ITN, CNBC, and Reuters. Also a Final Cut Pro Consultant and author of the best-selling *The Easy Guide to Final Cut Pro*.

Titles in the series:

The Focal Easy Guide to After Effects, Curtis Sponsler
The Focal Easy Guide to Cakewalk Sonar, Trev Wilkins
The Focal Easy Guide to DVD Studio Pro 3, Rick Young
The Focal Easy Guide to Final Cut Pro 5, Rick Young
The Focal Easy Guide to Combustion 4, Davis
The Easy Guide to Final Cut Pro 3, Rick Young
The Focal Easy Guide to Final Cut Pro 4, Rick Young
The Focal Easy Guide to Final Cut Express, Rick Young
The Focal Easy Guide to Maya 5, Jason Patnode
The Focal Easy Guide to Discreet combustion 3, Gary M. Davis
The Focal Easy Guide to Premiere Pro, Tim Kolb
The Focal Easy Guide to Flash MX 2004, Birgitta Hosea

THE FOCAL EASY GUIDE TO

PHOTOSHOP CS2

Image editing for new users and professionals

BRAD HINKEL

AMSTERDAM • BOSTON • HEIDELBERG • LONDON • NEW YORK • OXFORD
PARIS • SAN DIEGO • SAN FRANCISCO • SINGAPORE • SYDNEY • TOKYO
Focal Press is an imprint of Elsevier

ELSEVIER

Focal Press
An imprint of Elsevier
Linacre House, Jordan Hill, Oxford OX2 8DP
30 Corporate Drive, Burlington, MA 01803

First published 2006

British Library Cataloguing in Publication Data
A catalogue record for this book is available from the British Library

Library of Congress Cataloguing in Publication Data
A catalogue record for this book is available from the Library of Congress

ISBN 0 240 52001 7

For information on all Focal Press publications visit our website at:
www.focalpress.com

Typeset by Charon Tec Pvt. Ltd, Chennai, India
www.charontec.com
Printed and bound in Italy

Working together to grow
libraries in developing countries

www.elsevier.com | www.bookaid.org | www.sabre.org

ELSEVIER BOOK AID
 International Sabre Foundation

Contents

Chapter 3: The Image Editing Workflow 53

Chapter 5: Advanced Options 135

CHAPTER 1
INTRODUCTION

Digital technology is fundamentally changing the realm of photography and printing. Photographers now have almost unlimited options for editing their images to the precise look that they intend. Printing has become infinitely more flexible and pushed closer to the image creator. We can now use images in almost any form of visual communication. They have become a key element of the information revolution. This added flexibility brings more and more attention to the process of editing images. **Adobe® Photoshop®** is the essential tool for visual imaging. There are other simpler programs on the market, but most don't provide the essential tools for editing images accurately.

Photoshop is a very comprehensive program – probably the most complex program I have ever used. **My goal is to present Photoshop in an accessible way**. Even though Photoshop provides thousands of complex techniques for editing images, most users and most images don't need all this complexity. In fact, you only need to do a few basic steps in Photoshop to get the vast majority of images to shine. In this book, **I introduce you to the basic step-by-step process I use on most of my images**. This includes steps for editing density, contrast, and color plus basic techniques for image processing like converting images from color to black and white and sharpening images. My workflow is complete, but **I do not include many of the more complex and esoteric techniques** common to the Photoshop marketplace.

Take a quick look at the chapters of this book. They include the basic workflow for editing images: opening digital camera images, cleaning up images, basic adjustments, local adjustments, photographic processes, printing, and output to the web. They also include some Photoshop lessons (layers and masks, elements of the interface, and some special features) and lots of image editing techniques. If this seems sufficient for your work, let's get working.

Who Should Use this Book

This book is for people who want to learn the basic tools and image editing steps within Photoshop needed to create professional looking images. This, of course, includes **photographers, and graphics designers**, but also a wide range of **technicians and office workers who just want to do more effective image editing**. This book's focus is to provide insight into the how-to's of creating good

images, and not to showcase "cool" Photoshop techniques. I also don't pull any punches. I include all the key techniques necessary for good image editing: using layers and layer blending, curves, color correction, printer profiles, and more.

In my experience, most of my students have a good grasp of working with computers, **so I expect users of this book will have no problem navigating the computer, the menus, dialogs, or dragging a mouse. I do not expect the reader to have any experience with Photoshop**, although many readers will have good, basic experience playing with Photoshop.

Steps for Using this Book

This book includes three major chapters: Foundation, Workflow, and Advanced Tasks. The **Foundations** chapter includes basic information on Photoshop and digital imaging. The **Workflow** chapter describes the specific ordered tasks I recommend for a digital imaging workflow, including all the basic tasks necessary for image editing. The **Advanced Tasks** chapter includes a series of more complex step-by-step tasks for image editing that are used by imaging professionals. I have also included two chapters on **Printing** and **Web** images that provide instructions for outputting images to print and the web.

For those looking for a textbook on Photoshop image editing, you can work through the examples in this book in order. For those looking for a handbook on Photoshop, you can flip through the pages to find the specific task that interest you.

Conventions

Some helpful conventions are used throughout the book. **Important points are in bold type to** make it easier to skim through for specific information.

Tasks are numbered step-by-step and printed in dark blue.

1 The first step in the example

The conventional abbreviation **File>Browse** is used for selecting the Browse command from the File menu.

Special icons are used for identifying different types of information in the book.

 The Key icon identifies text in a chapter that summarizes a key point. Make sure you understand the key points of each chapter.

 The Details icon identifies text that expands upon the details of a certain topic. Details can be skipped over. Mostly they provide additional detail some people might want.

Photoshop Versions

This book is designed specifically for use with Photoshop CS2 released in the Spring of 2005. A number of new features are specifically addressed and identified by the Photoshop CS2 icon.

For the most part, the workflows and techniques described in this book still work well with the original Photoshop CS. For those specific to Photoshop CS2, a guide to similar techniques for Photoshop CS is available at the accompanying website to this book.

Apple Macintosh OS X vs Microsoft Windows XP Operating Systems

Although most of the screen shots in the book are taken from a computer running Windows XP, I am completely platform agnostic. I use Mac screen shots for some of the sections so that Windows users could see how similar Photoshop is on both platforms. In fact, Photoshop happens to be one of the very best cross-platform programs ever developed. With very few exceptions, every step on the Mac is identical to the same command on Windows. The differences that exist are identified as necessary in the text.

Two differences throughout are with regard to keyboard modifiers and mouse clicks. The two keyboards have essentially the same function keys, but different names. The Mac Command key ⌘ functions the same as the Windows **Ctrl** key *ctrl*. This keyboard modifier is identified as *ctrl* / ⌘ + (e.g., *ctrl* / ⌘ +**N**).

Similarly, the Mac "alt/option" key ⌥ functions the same as the Windows Alt key *alt*. This keyboard modifier is identified as *alt* / ⌥ +.

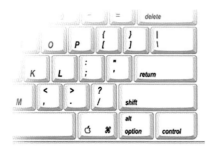

Finally, the standard Mac mouse includes only one mouse button. The Windows mouse includes a second mouse button for additional functionality – often a Context menu. Mac users can achieve this same functionality by holding down the **control** key *ctrl* when clicking the mouse. This mouse modifier is identified by *ctrl* **/right-click+** (e.g., *ctrl* **/right-click** inside a selection). Mac users could also just buy a mouse with two buttons. Ironically, the Microsoft mouse works great when plugged into a Mac.

This book supports Mac OS X 10.4. Although Photoshop CS2 works on Mac OS X 10.2.8 and above, there may be some minor differences to screens and printer dialogs for earlier versions of OS X.

This book also supports Windows XP Home with service pack 2. Photoshop CS2 also works on Windows 2000 with service pack 4 and Windows XP with service pack 1, but with some screen differences for the earlier version. Windows XP service pack 2 is a very good upgrade for most users.

Computer Requirements

What is the best computer for running Photoshop? Get a good, modest computer! Very high-end, expensive computers are definitely faster, but require careful configuration to achieve the best performance.

If you are purchasing a Windows-based computer, **buy the more advanced Intel Pentium or AMD Athlon processors**. They provide features that allow Photoshop increased performance over the lower priced processors. Apple has a simpler product line with the latest processor technologies.

I recently purchased two computers: a new iMac G5 and a new Sony Vaio RB30. Both are very modestly priced. The iMac was almost the cheapest configuration that I could buy, and the Sony had been recently heavily discounted. I then added an additional 1GB of RAM to both computers. Since **Photoshop performs much better with 1GB of RAM or more**, use the money you save on a cheap computer to buy the extra RAM. Both of these computers are faster than anything I had in my lab – frankly, I am very pleased with these systems. All you may need to do to your own computer to speed it up is to add more RAM.

Buy a good monitor The monitor is the interface between you and the image inside the computer. Bad monitors make it very difficult to edit images: you just can't see the details. Today's flat panel LCD monitors are excellent. The flicker free LCD display makes working in front of a computer much less tiring. You don't need to buy the best monitor on the market, but just avoid the cheapest LCD monitors. I suggest buying the second tier of any product line. Lastly, **if you want to do color correction, you need to calibrate your monitor**. Do it with a hardware device for calibration monitors. The Appendix on Monitor Calibration includes basic information on using a monitor calibration tool. **Calibrate your monitor as soon as practical**.

Web Site

I created a companion web site to supplement the content of this book at (www.EasyGuidetoPhotoshop.com). Most of the sample images used throughout this book are also available on the web site.

The web site also includes a number of additional sections on image editing provided as Adobe PDF files for download. These include:

- Steps for performing tasks in this book with Photoshop CS.

- A step-by-step lesson for learning the basics of layers.

- Instruction for scanning film.

- A chapter on combining multiple exposures into a single image.

- Advanced information on Printing.

Acknowledgments

My first thanks go to Christina Donaldson from Focal Press for suggesting this project, her timing could not have been more ideal for me to get started on this book. And Katrin Eismann who mentioned me to Christina as an appropriate author for this Focal Easy Guide title.

I especially need to thank those who gave me the opportunity to start teaching photography. Neil and Jeanne Chaput de Saintonge who hired me straight out of the RMSP summer intensive to start teaching their first digital photography courses, mostly because of Neil's instincts than my personal portfolio. Tim Cooper & Jim Hanson with whom I taught so many workshops and from whom I learned more about photography and enjoying it. Jennifer Schramm and Claire Garoutte who hired me at PCNW when the digital lab consisted of two computers in the back of a classroom.

My wife, Sangita for creating the last ditch effort to edit this book properly, and for her patience when I spent too many late nights in front of the computer; as well as too many weeks away from home teaching or photographing. And my aunt Jeannine who worked so intensely on wordsmithing my original text; and who we can all thank for adding "opine" to the text.

I would also thank Georgia Kennedy at Focal Press and Bryan Hughes of Adobe for providing valuable feedback on the book as I developed it.

Finally, I need to acknowledge Raja and Pablo for their late night support during this project. And Mira Nisa and Anjali for teaching me some perspective on what is really important.

Thanks to all – Brad Hinkel, Jun 2005
www.bradhinkel.com

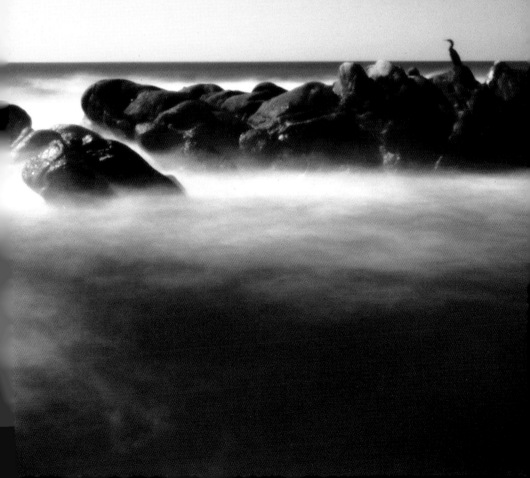

CHAPTER 2
FOUNDATION

Option bar Palette well

Toolbar

Palettes

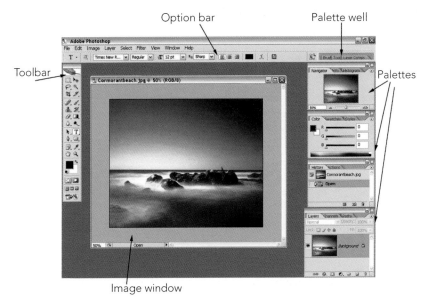

Image window

The main elements of Photoshop

A Look at Photoshop

This chapter introduces the basic interface of Photoshop: tools, palettes, the option bar, and image window. If you feel comfortable with these topics, skip to the next chapter. My main goal in this chapter is to identify the basic vocabulary of Photoshop used throughout this book.

The image above shows the main elements of Photoshop as they first appear. Ensure you have an image open if you want to experiment with the interface. Many Photoshop options are not available if no image is open.

The Toolbox

The toolbox holds the Photoshop tools. The tools allow you to work directly on the image: selecting, painting, adding text, etc. Generally you'll select a tool, move your mouse pointer over the image and

use the tool directly on the image by clicking on the image. Most of the tools change the cursor when the mouse moves over the Image Window to reflect the selected tool.

The toolbox includes a number of hidden tools. Access them by clicking and holding the mouse on a single tool icon. A tiny black triangle identifies the tools having hidden tools beneath.

Each tool has a set of options for customizing its function. When you select any tool, the option bar (just below the menu) changes to display the options for that tool.

You apply the default function for each tool merely by clicking or dragging the mouse on the image. Clicking on the image with the paint tool makes Photoshop paint the foreground color onto the image.

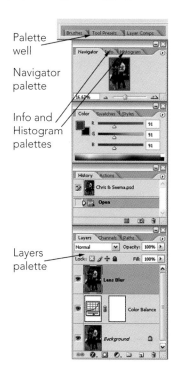

Palette well

Navigator palette

Info and Histogram palettes

Layers palette

The Palettes

Photoshop has many different palettes for evaluating and editing your image. Palettes are very useful for monitoring the various elements of your image, especially as your image gets complex.

Palettes can be visible, grouped, docked, or hidden.

Visible palettes are free floating in the workspace and can be moved around, resized, and grouped together to save space. Visible palettes can have other palettes grouped with them. These appear as name tabs behind the

visible palette's name tab. To make these palettes visible, just click on the name tab.

Palettes docked as tabs in the palette well allow one-click access without cluttering up your Photoshop workspace. Use the palette well to dock palettes that you often use, but do not usually need to see. Move palettes in and out of the well by dragging the palette name tabs.

Palettes are hidden when you close the palette window. A palette can be made visible again by selecting it from the **Window** menu.

Each palette has its own menu with options for customization. It can be accessed by clicking on the tiny arrow in the upper right of the palette.

The palettes can take up a lot of screen real estate and obscure part of your image. Hide all of the palette and the toolbox by pressing the **Tab** key; pressing **Tab** again makes them reappear.

Cleaning up the Palettes

When you first run Photoshop, there are 14 different palettes on the screen. For image editing, most of these are seldom used (if you don't have the default palettes displayed, go ahead and make them visible by selecting **Window>Workspace>Reset Palette Locations**).

So let's rearrange the palettes:

- Close the Color Palette window. The Swatches and Styles windows will also close.

- Click on the Brushes palette tab in the palette well and drag it out into the workspace. Now close it.

- Repeat to close the Tools Presets palette.

- Repeat to close the Layer Comps palette.

- Click on the History palette tab and drag it up into the palette well.

- Repeat to move the Actions palette into the palette well.

Now there is enough space to make the Layers palette larger. Move it up under the Navigator palette and resize it to fill more of the right side of the screen. **You'll use the Layers palette more than any other palette** and it will fill up quickly as you create new layers.

You can now access any of the visible and docked palettes by clicking on the tab for that palette. Take a look at the palettes that are left. You will use the Navigator, Info, Histogram, and History palettes in examples in this book.

The Navigator palette allows you to quickly change the zoom and view of your image in the image window.

The Info palette displays color information about the pixels that are under the cursor as it is passed over the image window.

The Histogram palette displays a Histogram for your image; the Histogram is a graph of the number of pixels at each density level. More on Histograms in the section on Basic Adjustment tools.

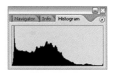

The History palette displays the past states of the image. You can use the History palette to quickly jump to older states, providing multiple levels of undo.

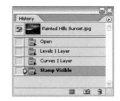

Once you have created a favorite layout for your palettes, save it. Select **Window>Workspace>Save Workspace...** and enter a name for your workspace. By default, Photoshop leaves your palettes where they are, and remembers their locations each time you close and reopen Photoshop. You can always return to a particular saved workspace by selecting the name of your workspace from the bottom of the **Window>Workspace** menu.

Menu customization Photoshop CS2 adds the ability to customize the items that appear on the menus. This is a terrific new feature since it allows you to clean up your menus by hiding many of the less used features in Photoshop. I have added some tips and suggestions for menu customization on the web site. I like this new feature, but I don't use any custom menus in this book.

Viewing the Image

As you edit your image, you will need to change the view of the image zoom in and out, pane around the image, and change the background Photoshop provides around the image. Two important views are "Fit on Screen" and "Actual pixels." The keystroke commands for changing the view of the image are very useful, since they allow you to change the view at any time, even if a tool is active (i.e., the crop tool) or a dialog box is open (i.e., Levels). It can be important to check out the view of the image as you are making edits.

Fit on Screen Often you will want to view the entire image as large as possible with the Photoshop window. This viewing mode is called "Fit on Screen"; access it by selecting **View>Fit on Screen**.

Fit on screen – Many image pixels are mapped to one screen pixel

In most cases, when the image is sized so to "Fit on Screen" there are many more pixels in the actual image than can be displayed on the screen. Photoshop compresses the images pixels into screen pixels. This can cause some artifacts in the view of the image. "Fit on Screen" works great for overall views of the image.

You can also select View Fit on Screen by double-clicking on the hand tool, or by pressing *ctrl* / ⌘ +**0** (zero).

Actual Pixels Sometimes you need to see each individual pixel for editing without any of the viewing artifacts of Photoshop. For this, use the "Actual Pixels" mode, select **View>Actual Pixels**. In this case, each image pixel is mapped to exactly one screen pixel. In most cases, you will only be able to see a portion of the image on the screen.

Actual pixels – images pixels are mapped directly to screen pixels
You see the real pixels....

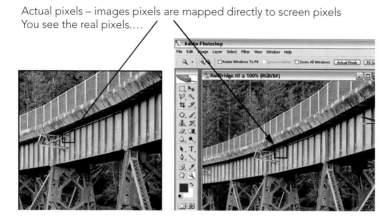

You can select View Actual Pixels by double-clicking on the zoom tool, or by hitting *ctrl*+*alt*+**zero** (⌘+⌥+zero).

Zooming In and Out It is easy to zoom in and out of the image in Photoshop. You can hit *ctrl*+**plus sign** (⌘+plus sign) to zoom in or *ctrl*+**minus sign** (⌘+minus sign) to zoom out.

The Hand Tool The hand tool is always available. Just hold down the spacebar to get the hand tool; click with the hand tool to drag the view of the image around to see other parts of the image. The hand tool used in combination with the zoom in and zoom out key commands allows you to see all of the details of the image.

Creating a New View You can also create a second view of the image easily; select **Window>Arrange>New Window** to add a view. These views all work on the same image, but can display different information independently. For example, one can display the whole image, while a second can display a zoomed in detail.

Navigator Palette The Navigator Palette displays a small thumbnail of the whole image, with a small, rose-colored box displaying the area visible in the image window. Moving your pointer into the Navigator window displays a hand tool that can be used to move the view of the image.

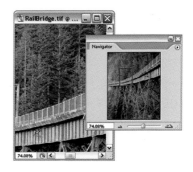

Tab key and F key The Tab key and F key can be used to quick change the Photoshop workspace around your image window. The Tab key hides and displays all of the Photoshop palettes. The F key switches Photoshop between Standard Mode, Full Screen Mode with Menus (your image will be placed center screen on the Photoshop workspace), and Full Screen Mode (your image will be place center screen on a field of black). These allow you to quickly view your image without much clutter. Try pressing Tab (to remove the palettes), F twice (to go to Full Screen Mode), and *ctrl* / ⌘ +0 to "Fit on Screen." Press Tab and F to return to the standard mode.

Accelerators

I'm not going to provide a long list of keyboard and mouse-click accelerators. A list is just not a practical way to learn them. But do learn some of them to make it easier to focus on editing rather than navigating each time through the interface to find a particular command.

Many accelerators are easy to find, though, in the Photoshop interface. Use the interface to find the appropriate accelerator, and then use the accelerator instead. You'll quickly get the hang of it. (This may sound trivial, but few people use this technique for learning accelerators.)

Menu accelerators are found next to the appropriate commands on the menu.

The toolbox shows tool tips for each tool. Point your cursor at a tool, wait a second and a tool tip will appear. The tool

tip displays the tool name plus the keyboard accelerator used to select it. As seen in the illustration, the brush tool can be selected by pressing the B key.

There are many additional accelerators hidden within Photoshop. I use a number of them, and, as necessary, identify them throughout the book. Photoshop also has a number of popup menus that accelerate access to various functions – they are typically identified by a grouping of small triangles (▾ ⊙ ◂). Click on some of them to see various popup options.

 Finally, you probably already know about the Undo key – **ctrl** / **⌘** **+Z**. This is likely the most important accelerator in Photoshop making editing safer knowing you can always undo a change that doesn't work out. Note, though, that the Undo command toggles between Undo and Redo, if you select **ctrl** / **⌘** **+Z** once it will undo, but a second time will Redo the previous command. This is great for evaluating the most recent edit.

Layers

Layers define the Photoshop model for image editing. **Understanding layers is the most essential step to understanding Photoshop**. The classic way to envision layers is as a stack of acetate sheets containing separate images. These combine together to create the final image as the image on the top piece of acetate overlays the images beneath it.

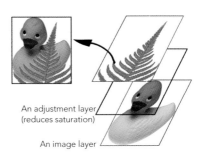

An adjustment layer (reduces saturation)

An image layer

There are two key classes of layers: Image layers and Adjustment layers.

Essentially image layers are completely separate images that can be stacked on top of one another to form the final image. (Photoshop refers to these as just "Layers," but I use the term "Image Layers" to distinguish them from other layers.) The background layer, at the bottom of the stack, is the image layer containing your initial image. Copies of the background layer can serve as new layers on which you can make changes in the image.

Adjustment layers don't contain any image, only a specific adjustment to the image beneath it. You can apply many adjustment layers to your image to change it's brightness, contrast, and/or colors.

The whole image is a blend of the stacked image and adjustment layers from the bottom up – adjustments applied, images added to form the final desired image.

The Layer Masks

Layers often have an associated black and white mask. A mask defines where it's layer is visible or hidden. You can use a mask to localize the effect of an adjustment layer, or localize where an image layer is visible. Where the mask is white, either the image or the adjustment is visible; where it is black, either is hidden. By default, the mask is entirely white, that is, the associated layer is completely visible. The key to working with masks is to control where the mask is partially black and partially white.

Masks are often created in combination with selections. Selections define a region of an image and these can be converted into masks. You will learn to use Selections to create masks in the Section on Localized Adjustments in the Workflow chapter. Masks can also be painted on with black or white using the paint brush tool.

Look at the layers used to create this image.

1 The original image is contained on the background layer.

2 I created a copy of the background image named "Blur Layer" and blurred it. For the "Blur Layer," I then created a mask that is white on the left to reveal the blur over the water and black everywhere else.

3 I created an adjustment layer named "Darken" leaving its mask default white.

4 Finally, I created an adjustment layer named "Snow Contrast." For this layer, I created a mask that is white on the right to reveal the snow and black everywhere else. Thus the contrast adjustment is applied only over the snow.

5 The final blended image results with blurred moving water, the entire image darkened, and contrast added to the snow.

You'll be doing a lot with masks: creating them, painting on them, editing them. Usually, you won't see the masks on the screen, just your image. You need to realize that the mask is an inherent part of the layer. Often you'll be editing the mask without even seeing it.

A Look at the Layers Palette

The layers palette shows the status for all the layers in your image.

As illustrated, the background layer is always labeled *background*. It is a special type of image layer. It must always be the bottom layer, cannot have a mask, and is, therefore entirely visible.

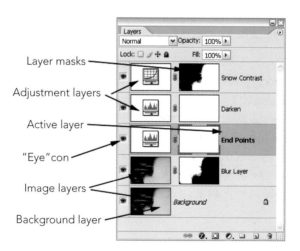

Layer masks

Adjustment layers

Active layer

"Eye" con

Image layers

Background layer

Each image layer has its own thumbnail displayed to the left and any associated mask to the right, not all image layers have an associated mask.

The Active layer is the currently selected layer. Any edits you make apply to the Active layer.

Each Adjustment layer has icon representing the type of adjustment displayed to the left and its associated mask to the right, by default all adjustment layers have an associated mask.

The eyeball to the left of each layer is often called the "eye-con." Click it on or off to make visible or invisible its effect on its respective image layer. **alt** / **⌥+click** on the eye-con for any layer and the effects on the image of all the *other* layers become *invisible*. **alt** / **⌥+click** again and the effects of all the other layers become *visible* again.

Many readers of this book may already be comfortable working with layers. But if you want more practice with layers, visit the web site and download lesson, "Starting with Layers."

Adjustment Layers

You can apply the basic adjustments to your *background* image directly by using the individual adjustment tools; these are found under the **Image>Adjustments** sub menu. These tools apply their adjustments to an image. Once the adjustment is applied and the image changed; these changes are irrevocable.

You can also apply the same adjustment tools using adjustment layers. These act as filters over your image to apply the adjustments as the image is viewed (or printed), but do not actually alter the underlying image. The adjustment layers can be created under the New Adjustment Layer sub menu. Many of the adjustment options available under

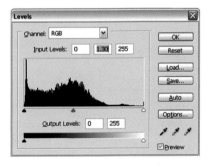

Image>Adjustments have a corresponding adjustment layer available under Layer>New Adjustment Layer.

 Whenever possible, it is best to apply adjustment layers rather than applying the adjustments directly to the image, select the Layer>New Adjustment Layer menu, not the Image Adjustments menu.

When you first create an adjustment layer, Photoshop displays the New Layer dialog so you can provide a name for the adjustment layer. **Name your layers based on the Adjustment task that it will perform on your image**, something like "Brighten" or "add Contrast", this makes it much easier to find the

appropriate adjustment layer when you are editing the image at a later time. Once you have named the new layer, the appropriate adjustment dialog will appear and allow you to apply that

adjustment. Selecting OK, creates the adjustment layer and applies the adjustment.

The new adjustment layer will appear on the layers palette. Each type of adjustment layer has an associated icon to identify it. You can turn on or off the adjustment for each layer by clicking on the "eye-con." Each adjustment layer also has an associated mask. These are completely white by default, but can be mixed black and white to localize where on the image to apply the adjustment for this layer.

One significant advantage of adjustment layers is the ability to return to the adjustment dialog and fine-tune your adjustments. This is often referred to as "non-destructive" editing; since the underlying *background* image is not actually changed by the adjustment layer, just the combined displayed or printed image. To

change the adjustments in an adjustment layer, double-click on the layer icon for the adjustment layer that you wish to edit. The adjustment dialog will appear; showing the previously applied adjustment. You can then fine tune your adjustment. Using multiple adjustment layers, it becomes easy to apply each adjustment, and then go back and edit each one until the cumulative effect creates the desired results.

You will use adjustment layers signification in the Basic Adjustments and Localized Adjustments sections of the Workflow chapter.

Some Notes on Layers

Selecting the image or the mask One of the biggest confusions many new users have with Photoshop is determining if a layer or its associated mask is selected. It isn't very obvious in the Photoshop interface.

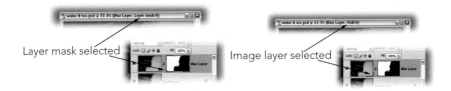

Layer mask selected

Image layer selected

If you click on an image thumbnail, its respective image is selected. You can tell by the addition of a thin black line around the image thumbnail in the layers palette and by a "color-mode" reference in the image's title bar, typically "RGB", "CMYK", or "Gray." Any painting or other editing then directly changes the image part of the image layer.

If you click on the associated mask thumbnail for an image layer, its respective mask is selected. You can tell by the addition of a thin black line around the mask thumbnail in the layers palette and by a "Layer Mask" reference in the image's title bar. Any painting or other editing then directly changes the associated mask of the image layer.

Since Adjustment layers have no image, if you click on an adjustment icon, it's associated mask is always selected. Any painting or other editing then directly changes the associated mask of the adjustment layer.

Inadvertently editing the wrong "selected" element (image vs mask vs adjustment) is probably the number one problem many people encounter when editing images in Photoshop. Don't worry, though, if you do an edit on the wrong element. Just undo the last step, select the element you really want, and repeat the edit.

Naming layers It is very important to name your layers. Although Photoshop assigns default names to all layers like "Background copy" or "Curves 1," these provide little useful information. Assigning your own useful names makes it easier to find and edit the appropriate layers later. If you create or duplicate a layer using the menu (or the keyboard accelerators listed on the menu), Photoshop provides you with a dialog to name the layer before creating it. Even if you end up with a default name for your layer, double-click it and Photoshop will let you rename it.

Copying layers It is possible to copy a layer from one image onto another image merely by dragging the layer from the source image and dropping it onto the destination image. You can also copy a layer from one

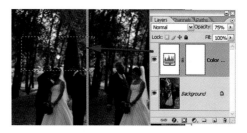

image to another by selecting the layer in the source image and using the **Layer>Duplicate Layer** command. In the **Duplicate Layer** dialog, change "Destination Document" to the destination image.

Layers palette icons Along the bottom of the layers palette are several icons you can use to quickly edit your layers.

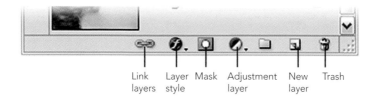

Link Layer Mask Adjustment New Trash
layers style layer layer

Click on the Trash icon to delete the current layer. Or you can drag a layer to the Trash icon to delete it.

Click on the New Layer icon to create a new layer. Or you can drag any layer to the New Layer icon to make a copy of it. Hold down the *alt* / ⌥ key when dragging a layer to this icon and Photoshop will give you a dialog to name the new copy.

Click on the Adjustment Layer icon to get a menu for the adjustment layers available in Photoshop. Select one to create it. Hold down the *alt* / ⌥ key when selecting an adjustment layer and Photoshop will give you a dialog to name the new adjustment layer.

Click on the Mask icon to create a new mask. Photoshop creates a mask that is either white everywhere or a mask that mimics a selection if you have a selection on the image. You only need to create a mask for image layers, since adjustment layers automatically have an associated mask. If your image layer already has a

mask, it is possible to create another mask (a vector mask), but don't do it! Usually one mask is enough.

Layer Styles and Linked Layers are advanced topics not covered in this book.

Merged Image Layers

Adjustment layers are great; however some of Photoshop's more useful adjustment tools and all of its filters only work on a single image layer, not on a stack of layers. Important tools that cannot work with adjustment layers include the Shadow/Highlight adjustment tool, the Blur filter, and the Sharpen filter. To solve this problem, I've created the concept of a *Merged* Image layer. A Merged Image layer is the "top" or "final" blended image of a stack of layers, a single new image layer on which you can apply these "single-layer-minded" tools and filters. In essence, I'm creating a new background image. To create a Merged Image layer, follow these steps:

1 Make sure the top layer of your stack is selected. The Merged Image layer will be created on top of the selected layer.

2 Hit ⌘ / ⌥ / Shift +E or ctrl / alt / Shift +E (a real finger trick!). Or you can select **Layer>Merge Visible** while holding down the ⌥ / alt key. This takes the current blended version of all the visible layers and copies it into a new merged layer.

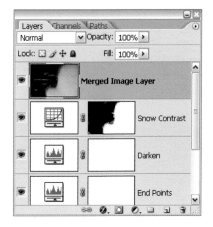

3 Change the name of this layer to reflect the adjustment you'll be making, e.g., "sharpening layer." It's very important to have a useful name here so you can recreate this layer later if necessary.

4 Now apply the appropriate adjustment or filter to this new merged layer.

One major problem with Merged Image layers is that they can completely obscure the layers beneath. When you change a layer beneath a Merged Image layer, you can't see these changes in the image. If you want to change a layer beneath a Merged Image layer or the Merged Image layer itself, you have to recreate the Merged Image layer.

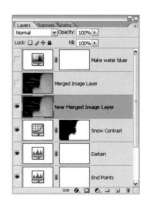

1 Make all the layers above the Merged Image Layer invisible by clicking on each "eye-con" to turn them off. Make the Merged Image Layer invisible as well, you'll create a new Merged Image layer to replace this one.

2 Make any adjustments you want to any layers beneath the Merged Image layer.

3 Select the layer just beneath the Merged Image layer you want to replace. Press ⌘ / ⌥ / Shift +E or ctrl / alt / Shift +E to create a new Merged Image layer.

4 Apply the adjustment or filter made to the old Merged Image layer again to this new Merged Image layer. This reinforces the value of a good initial "clue"-name for the original Merged Image layer.

5 Select the old Merged Image layer and drag it to the trash.

Creating Merged Image Layers implies that you have several layers to merge; you cannot create a Merged Image Layer from the background layer alone. **Single-layer-minded tools should not, though, be applied to the background layer on its own**. If you only have a background layer in your image, first make a duplicate image layer on which to apply any of these adjustments. Select **Layer>Duplicate Layer** and then apply the single-layer-minded tool.

Photoshop Brushes

A brush defines the image area that certain Photoshop tools will affect. Photoshop has a number of tools that use a brush, e.g., the paint brush tool, and the healing brush tools. A brush appears as a circle as you move the cursor over the image. Being able to edit the brush quickly and easily makes overall editing much easier. The basic techniques for manipulating brushes are so important that I have listed the steps here and refer back to them whenever I introduce a new brush.

Brush Color

The paintbrush tool uses the foreground color as its paint color; the eraser tool uses the background color as its color. **The best colors for painting are often the default colors of black and white. Use the D key to set the default colors.** You will commonly paint on layer masks, for which black and white are useful colors.

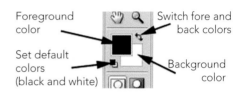

Foreground color

Switch fore and back colors

Set default colors (black and white)

Background color

If you need to switch the foreground and background colors, **use the X key**.

If you click on the foreground or background color squares, Photoshop will display the Color Picker. Use this to select colors other than black or white.

Brush Size

When you move a brush over your image, Photoshop displays a circle that represents the size of the brush. If the brush is very small, Photoshop displays a small crosshair. You can change the brush size from the Brushes palette or from the Brush section of the option bar, but it is easier to **change a brush size using the square bracket keys "[" or "]"**.

Once you get used to the keys, it becomes much easier to select an appropriate brush size. You can also give your brush a harder or softer edge by pressing +[or].

Brush Opacity

Lastly, there are times you'll want to apply a brush lightly or heavily. In general, **do not change brush color to change density, change brush opacity**. When using the Paintbrush tool, opacity represents the amount of black, white, or color a brush lies down as you drag the cursor across your image. By changing opacity, you change how thickly you apply the color with the brush: 10% opacity translating as thinly, 50% more heavily.

The opacity level is changed by pressing the number keys: 1 for 10% opacity, 2 for 20% . . . up to 9 for 90% and 0 for 100%. When you press these keys, the brush opacity changes on the option bar.

Try a simple exercise with the paint brush:

1 Open an image in Photoshop. Select the Paintbrush tool, simply press **B**.

2 Move the cursor over your image and you'll see a circle, i.e., the paint brush. Resize the brush using the [] keys.

3 Set the foreground and background colors to the default colors, simply hit the **D** key. Paint with the brush on your image. Change the hardness of the brush edge using *Shift* +[].

4 Change the brush opacity using the number keys and paint some more. Switch the foreground and background colors using the **X** key. You should be able to paint various shades of grey over your image easily. Even with a low opacity value, you should be able to paint a part of the image to pure black or pure white by repeatedly painting over the same spot.

5 Next create a new adjustment layer; color balance is easy to try. Select **Layer>New Adjustment Layer>Color Balance**. Name this new layer "Lots of Red." In the Color Balance dialog, make a strong adjustment by adding lots of red. Hit OK to close the dialog.

6 The image will now appear very red. The "Lots of Red" layer will also appear in the layers palette. And the Title for the Image window will include the text (**Lots of Red, Layer Mask**).

7 Use the paint brush tool to paint on this layer mask. If your brush color is white, you'll merely be painting white onto a white mask, so start with a black brush. Remember, pressing **X** switches the fore and background colors. You should be able to mask the red adjustment.

8 Experiment with changing the brush size, the brush edge hardness, the brush color, and the brush opacity. Notice how using a soft edged brush and a moderate opacity can make the painting edges softer.

Make a habit of using the quick keystrokes as you work with the brushes so you won't need to move you mouse away from the image to make these changes. It'll make editing a breeze.

Basic Adjustment Tools

Histograms

The Histogram is one of the key tools in digital imaging. It provides a graph of the density values of an image. The Histogram shows the number of pixels at each particular density value. The left-most point of the Histogram is pure black (very dense), the midpoint gray, and the right-most point pure white (no density). A big peak in any of these regions means the image has lots of

pixels at this density; an open gap in the Histogram means there are no pixels at this density.

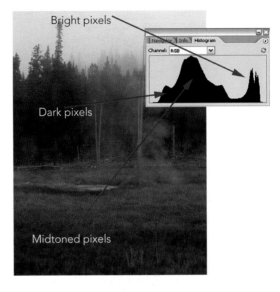

Use the distribution of the Histogram to determine the overall exposure of an image. The rule of thumb is that an image looks best if it contains values at both the dark and light ends. Without some dark and light values, the image may lack contrast and appear flat. If you have a strong peak at the bright or dark end of the Histogram, it's possible your image is over or underexposed. Much depends on the individual image and personal aesthetic.

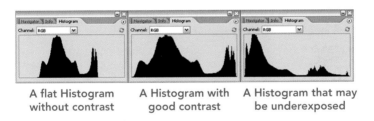

A flat Histogram without contrast **A Histogram with good contrast** **A Histogram that may be underexposed**

The Histogram is also used to depict the smoothness of tones of an image. The illustration below shows from left to right:

1 A smooth Histogram representing an image with a full range of tones. You can edit this image extensively without concern.

2 A Histogram with a few strong spikes or gaps representing an image with some gaps in tone. You need to be careful about heavily editing this image.

3 A Histogram with a comb-like appearance representing an image with sparse tones. This image may appear blotchy or posterized especially when printed.

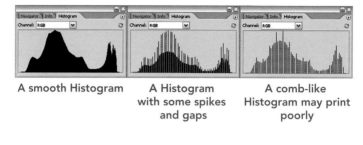

A smooth Histogram **A Histogram with some spikes and gaps** **A comb-like Histogram may print poorly**

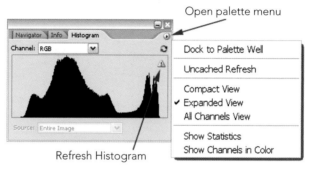

Open palette menu

Refresh Histogram

The Histogram palette provides a real-time Histogram of the active image as it is being edited. Typically it docks behind the Navigator palette, click on the Histogram tab to bring it forward. Here are a couple of tips to keep in mind when using this tool: First, make the Histogram display as large as possible. Do this by opening the Histogram palette menu and selecting "Expanded View." Second, the Histogram palette uses cached data to update the Histogram in real-time, but this cache quickly gets out of date and inaccurate. When this happens, Photoshop displays a cached data warning icon. Click on this icon to update the palette and get an accurate Histogram.

Finally, the Histogram immediately shows the effects of an adjustment on the image. New adjustments made to the image appear in black overlaying the old ones which appear in gray. This real-time feedback allows for quick decisions on how much to edit your image.

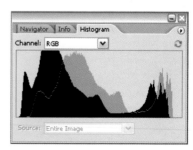

Levels

To refine your image to have full contrast and to adjust the image brightness, use the Levels Adjustment tool. It's the best tool for defining black and white points, making the overall image lighter or darker, and doing color correction. To access the Levels dialog, select **Layer>New Adjustment Layer>Levels**.

As illustrated, the Levels dialog contains a Histogram with slider controls. You'll learn more about the use of the sliders with individual-channel Histograms, color, and eyedroppers in the Advanced Options chapter. For now we'll only address the operational function of:

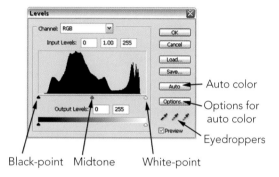

Auto color

Options for auto color

Eyedroppers

Black-point Midtone White-point

- ■ The Black-point slider.

- ■ The Midpoint slider.

- ■ The White-point slider.

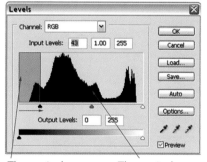

These pixels are made pure black

These pixels are shifted darker

The black-point slider can be moved to set which pixels set to pure black. All the pixels represented in the Histogram directly above the black-point slider (and those to its left) will be changed to pure black, and all the other pixels in the image will be shifted darker towards the black point making the image darker.

The white-point slider similarly sets the pure-white pixels and makes the image brighter.

Adjusting both the black and white-point sliders stretched the image towards both the black and white ends, resulting in an increase in image contrast.

The midpoint slider sets the middle-gray pixels. At the same time, it sets all the pixels to the left darker then middle gray and those to the right brighter than middle gray. This may seem counter intuitive since you slide the midpoint slider towards the white slider to make the image darker, but the image preview displays the change to the image as you adjust it.

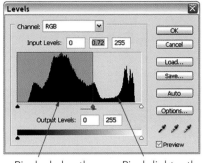

Pixels darker than middle gray Pixels lighter than middle gray

The preview checkbox is key to all the dialogs in Photoshop. Turn it on to see the effect of the current dialog in the image window, and off to see the image before this effect. (Windows toggles this action via *alt* +P.) This is great for checking out subtle changes to your image before you save them.

The levels dialog is commonly used with two basic adjustment types: setting black and white points, and changing image brightness.

The Black and White point adjustment is very simple: merely drag the Black and White-point sliders in far enough so the images has some black pixels and some white pixels. This is often the single best adjustment you can make to an image since it ensures good overall contrast.

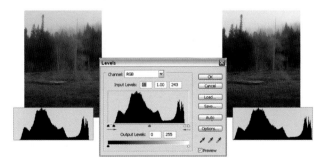

The Brightness adjustment is similarly very simple: merely drag the midpoint slider to the left or right to alter overall image brightness.

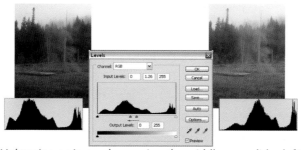

Lightening an image by moving the middle gray slider left

One of the advantages of Levels adjustment is it allows changes to the brightness of midpoint pixels without major changes to shadow (black) or highlight (white) pixels. This is why you should use the Levels dialog to adjust brightness and *not* the Brightness/Contrast dialog.

Curves

To refine your image tones with more precision use the Curves Adjustment tool. The curves tool is commonly used to add contrast to the image and to make precise adjustments to individual tones in the image.

To access the Curves dialog, select **Layers>New Adjustment Layer>Curves.**

When the Curves dialog is opened, the default curve is a straight line. The straight line maps the input values to the output values leaving the image unchanged. The horizontal axis is the input values for the tones; the vertical axis, the output values. The tones are displayed on the bottom and left of the curve as a

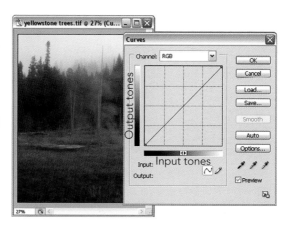

black to white gradient. Use this gradient to visualize the various tones as you adjust your image.

To make a simple curve, click on the curve line to create a gradation point, and drag the point upward. (*Note:* You can also use the keyboard arrow keys to move gradation points.) This is a classic brightening curve.

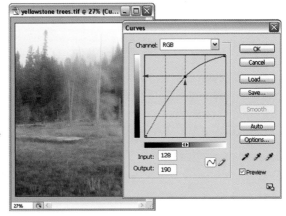

Midtone values are mapped to brighter values, thus brightening the overall image

Click on another part of the curve to add a second point and drag it around to see the effect on the curve. Points can be removed simply by dragging them outside of the curve box.

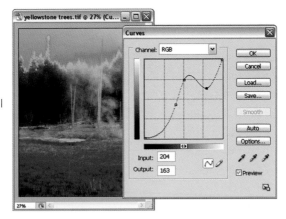

Complex curves can create radical changes to the image

Some notes on curves

As with the Levels dialog, you'll learn more about the use of the Curves dialog with individual-color channels, auto color and eyedroppers in the Advanced Options chapter.

Channel affected by curve

Auto color

Options for auto color

Eyedroppers

Precise input and output values

Switch curve from brightness to ink density

Large/small curves dialog

Also, make the Curves dialog as large as possible. Do this by selecting the "Large/Small" icon in the lower right of the dialog box.

In grayscale images, Photoshop reverses the direction of the curve gradient (from light to dark rather than dark to light). Use the icon in the center of the gradient to switch the direction of the gradient. (I prefer a "dark to light" direction.)

Some sample curves There are many different types of edits you can perform with the curves tool. In fact, some Photoshop gurus claim they can do almost everything using curves. Here are a couple of basic examples for changing image brightness and adding contrast.

To change image brightness, open the Curves dialog (create a curves adjustment layer), click near the center of the Curve line to create a point, and

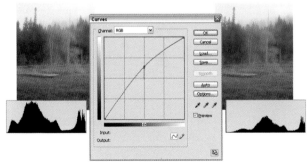

drag the point up. This makes the pixels in the image brighter.

To add contrast to the image, open the Curves dialog, click on the curve to create a point at the quarter-tone of the image (about ¼ of the way from the white point) and another at the three-quarter tone of the image (about ¼ of the way from the black point). Move the quarter-tone point upward (brightening the brighter pixels of the image). Move the three-quarter point downward (darkening the darker pixels of the image). Now we have a classic "S-curve." Contrast is added by darkening the dark pixels and lightening the bright pixels.

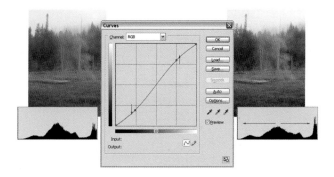

The S-curve preserves the values of the black and white points in the image, it doesn't push any pixels to pure black or pure white. This is why you should use the Curves dialog to adjust Contrast *not* the Brightness/Contrast dialog.

Very small adjustments made in the Curves dialog make very significant changes to the appearance of your image. The curves tool is all about subtly, often less is more when using curves. Once again, the Preview option proves invaluable. Toggle it on and off to check out the effect of these subtle changes.

Color Balance

To refine the image's overall color balance and eliminate any color cast, use the Color Balance tool. With this tool you can add or remove Red, Green, and Blue from the image pixels.

To access the Color Balance dialog, select **Layers>New Adjustment Layer> Color Balance...**

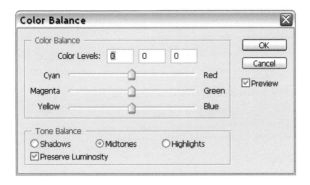

The Color Balance tool actually makes a lot of sense once you understand the basic theory of color wheel use in Photography and Digital Imaging. In photography and in computers, color is created by mixing Red, Green, and Blue values from the Red, Green, and Blue color wheel. (You may have heard of other color wheels used in painting.) Colors complementary to Red, Green, and Blue are Cyan, Magenta, and Yellow, so changes in R, G, & B also force changes in the values in C, M, & Y. It follows then that adding one

The RGB color wheel

color automatically implies removing its complement. So, adding Red is the same as removing Cyan.

The Color Balance tool is therefore very simple to use. If your image has too much overall Green, then add Magenta (and remove Green) by moving the slider between Magenta and Green left towards Magenta. Be careful when using the Color balance tool to identify the various color cast in your image. Often what appears as a Blue cast (especially blue in shadows) is actually a Blue/Cyan cast, which requires adding Yellow and Red.

The Color Balance tool also allows you to adjust the colors based on the overall image tone. By default, the tone balance is set to "Midtones," so that color changes appear strongest at the Midtones, and weaker in the Shadows and Highlights. This setting works best for applying overall changes to the image color balance. It is also possible to make color changes that are localized to the shadows or highlights in your image by switch to "Shadows" or "Highlights."

The Color Balance tool is useful to learn the basics of editing color in digital images. For basic image adjustments, work with the Color Balance tool.

But the Color Balance tool isn't really the best tool to use for performing color balance (classic Photoshop). In the Advanced Options chapter, you will learn to use the Levels tool for more precise color adjustments.

Hue/Saturation

To make changes to individual colors in the image, use the Hue/Saturation tool. With this tool you can make changes to individual ranges of colors in the image; e.g., you can change the cyan pixels to make them bluer, or you can change the red pixels to make them more saturated. This is a powerful tool to make subtle but effective changes to colors.

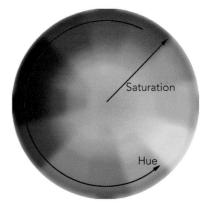

Digital colors are typically represented by values of Red, Green, and Blue. Colors can also be represented by values of Hue, Saturation and Lightness (HSL). The Hue provides a value for the shade of the color (red, orange, yellow, etc.) and the Saturation a value for the intensity of the color.

As the Color Balance dialog allows changes to R, G or B values, the Hue/Saturation dialog allows independent changes to Hue, Saturation, and Lightness values.

To access the Hue/Saturation tool, select **Layers>New Adjustment Layer> Hue/Saturation...**

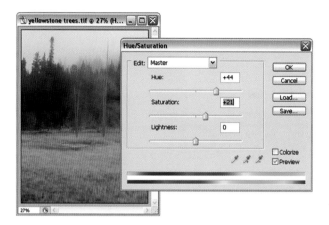

When the Hue/Saturation dialog is opened, **it defaults to editing all of the colors in the image**. Adjusting the Saturation slider increases or decreases the saturation for every color in the image. Adjusting the Hue slider shifts the color of every color in the image; **usually, this is not the desired result**. Adjustments to Hue shifts the adjusted colors around the color wheel, in the example shown, blues are shifted to purple, reds to yellow, yellows to green, and so on. The color bars at the bottom of the dialog display these color shifts.

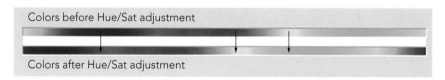

The Hue/Saturation tool becomes much more powerful when it is localized to affect only a narrow range of colors. Change the Edit option from "Master" to one listed colors. Now a range is displayed between the color bars.

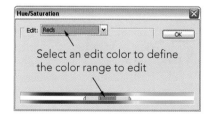

To more precisely select a specific color, move the mouse pointer over the image (the pointer will change to the eyedropper), use the eyedropper to select a color from the image. The Color range will be adjusted to select this color.

With a specific color range set, the Hue/Saturation tool becomes a much more effective color editor. Adjustments to HSL will only affect the specified color range.

Select a color from the image to set the color range to edit more precisely

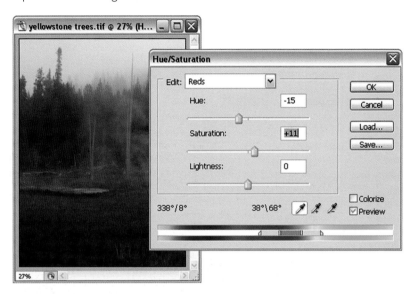

The Hue/Saturation tool is very powerful for making subtle changes to individual colors, by changing the hue, saturation, or lightness of the color. For example, you can "make the orange grasses redder" (as above), or "make the cyan sky bluer", or "make the blue water more saturated", and so on. It is common to create many different Hue/Saturation adjustment layers on a single image that each make small color adjustments.

The Hue/Saturation tool can easily be overused. Small changes to hue, saturation, or lightness can be fairly dramatic. Be subtle.

Geeky Stuff

(Everything you ever really wanted to know about bits but were afraid to ask.) This section covers the technical details of how computers deal with digital images. Many people just want to skip the technical details because they're

about the geeky inner workings of the computer. But it is useful to have a basic understanding of how Photoshop "sees" your digital image. I break down these details into a fairly straight-forward glossary of terms: Digital Images, Pixels, Resolution, Bits, etc. As much as software engineers try to hide the technical details of image editing, these terms still pop up over and over again in digital photography. You may already know many of the details of computers, but review the terms as I define them here anyway. They're often used incorrectly with regard to digital imaging.

A Digital Image

Computer software programs in general (including Photoshop) see digital images as a rectangular array of pixels. Each pixel is merely a tiny square of color. This image of the dragonfly is composed of an array of 750 × 750 pixels, or 562,500 pixels. A typical digital camera image might have 2000 × 3000 pixels, or 6 mega pixels. Most digital images contain millions of pixels, thus the common term "mega pixels."

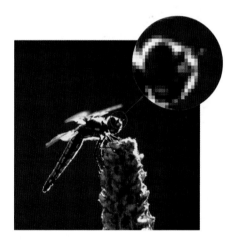

Digital Images are merely a rectangular array of pixels that represents your image. Digital images typically contain millions of pixels.

Pixels

Pixels are, therefore, the most basic element of a digital image, a small square of color. But pixels have no size; in fact, pixels only exist within the computer. A closer look at a pixel reveals that it is no more than a simple set of numbers used to describe a color. For most images, each pixel contains a Red (R), Green (G), and Blue (B) value. The computer uses these RGB values to create the color for that particular pixel. Grayscale images don't use RGB values. They use only one

number for each pixel to represent "black" density. It is important to remember computers only think in terms of number values, and your image is broken down into an array of simple numbers for each pixel.

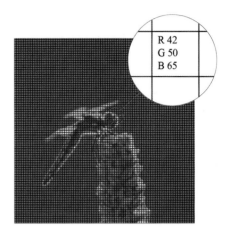

R 42
G 50
B 65

 Pixels are simple, square elements that make up a digital image. Pixels have no size and exist only with the computer. Pixels contain simple numbers that describe its color.

Channels/Color Models

The red, green, and blue parts of the color image can be separated into three distinct images referred to as "channels." Typically these are displayed in grayscale. You can see the channels for your image by selecting the channels palette in Photoshop.

RGB is one of several color modes available in Photoshop. **For photography, color digital images should (almost) always be in RGB mode.** Digital cameras and scanners capture information in components of red, green, and blue. And most desktop printers, as well as many large professional photo printers, also work in components of red, green, and blue.

But don't printers work in CMYK? Yes, generally most printers create colors by mixing CMYK inks. Cyan, magenta, and yellow are the complementary colors of red, green

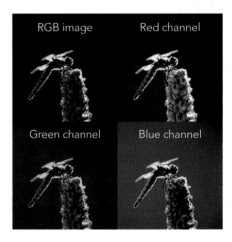

RGB image Red channel

Green channel Blue channel

and blue. And CMY inks need to be used to create colors when mixing ink onto paper. But the conversion from RGB images to CMYK images is something best left to professionals. In the case of desktop printers, the printer driver only accepts RGB values and performs the conversion from RGB to CMYK within the printer driver. **Don't worry about CMYK color mode, the printer driver or professional print shops deal with these**.

 For digital images there are really only two important color modes: RGB and Gray. RGB has three color channels: Red, Green, and Blue. While the Grayscale only has one channel: Gray.

Bits and Bytes

Computers are binary devices. At the simplest level, all numbers within a computer are made up of bits. Bits can only have the values of 1 or 0, or, that is, yes and no. Bits are grouped together into Bytes. There are 8 bits in a typical byte, providing a range of values from 0000 0000 to 1111 1111, or 0 to 255 in decimals that we commonly understand. Traditionally, the color represented by a pixel is stored in 3 bytes, one each for red, green, and blue. This is the reason that Photoshop often represents the values of colors with the range from 0 to 255, the range of values for 1 byte. We'll see this range of 0–255 throughout Photoshop and digital imaging. A color pixel has three such numbers for each red, green, and blue; R100, G58, B195 is a rich purple. A grayscale pixel only has one number representing the density of the pixel from black to white.

The Histogram in Photoshop becomes simply a graph of the number of pixels at each byte value from 0 to 255.

Today, it is very common for pixels to have more than 1 byte of information for each color in each pixel. We still refer to these colors as having the range of 0–255, but the second byte allows for more precision in each of these numbers. A 1-byte color represents color from 0 to 255 in whole increments, but a 2-byte color represents color from 0 to 255 with fine intermediate increments allowing such values as 58.55. Color can be described much more precisely with 2 bytes.

Bit Depth

The number of bits used for each color channel in a pixel is referred to as the Bit Depth. An image with pixels that uses 1 byte per channel (or 8 bits per channel) is referred to as an 8-bit image or as having a bit depth of 8 bits per channel. The vast majority of digital images have 8 bits per channel. This allows for 255 different values of each red, green and blue or ideally 16 million possible colors. For the vast majority of printing or display options, this is more than sufficient for representing colors. But in the world of digital image editing, more bits are often desired. Scanners and digital cameras often create files with more than 8 bits per channel, each of these options provide the same range of values (0–255), but the extra 8 bits provide intermediate values for finer precision (i.e., values like 100.254 rather than 100). When editing images, it's possible that significant edits will result in operations that reveal the limited precision in 8-bit images. Here, a moderate field of blue has been expanded to cover densities from bright blue to

dark blue. A version with 8 bits per channel doesn't have sufficient precision to display across this entire range of colors, resulting in an image with several discrete values of blue. This is often referred to as posterization. The version with 16 bits per channel has sufficient precision to edit across the full range of colors and display a smooth gradation of colors.

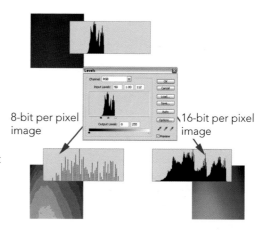

8-bit per pixel image

16-bit per pixel image

When scanning images or capturing digital camera images, it's best to try to create images with more than 8 bits per channel. Most scanners allow for scanning at more than 8 bits. Digital cameras that support RAW files allow for more than 8 bits, as well. Jpeg files only support 8 bits per channel. (This is the main limitation of using Jpeg files for capture in digital cameras.) Jpeg files still can be used for digital capture, but cannot be edited as well as RAW image files.

When devices with 12, 14 or 16 bits save files, they always save the files with two full bytes per color channel per pixel. These are all represented as 16 bits per channel when the files are open in Photoshop. For the most part, these are good ranges for digital image editing. I often refer to images as having 8 bits per channel (limited editing), or more than 8 bits per channel (edited freely).

 When editing in Photoshop, start with images that have a bit depth of 16 bits per channel.

Bit depth is also often referred to in terms of bits per pixel (bpp). If each pixel has three colors channels, each with 8 bits, these images have 24 bits per pixel. Images with 16 bits per color channel have 48 bits per pixel. Bits per pixel (bpp) is often used incorrectly to mean bits per *channel*. Just remember that 8 bits per color/channel limits the type of image editing you can do, while more than 8 bits (i.e., 16 bits per channel) provides for very extensive editing.

Image Size

The size of a digital image is referred in several different ways. The most informative, and least common, method is to refer to its horizontal and vertical dimensions, a typical image might have a size of 2000 × 3000 pixels. This provides information about the shape of the image as well as its size. But the most common way to refer to image size is to refer to its overall number of pixels, multiplying the horizontal by the vertical dimensions. In this example getting a result of 6,000,000 pixels or 6 mega pixels.

Finally, it is also common to refer to image size in terms of megabytes (MB). Traditionally, computers used 3 bytes of information to store 1 pixel. By multiplying the number of pixels by 3, you get the size in MB, or 18 MB in this example.

Dots and Sensors

Typically, my definition of pixels often leads to the question about the resolution of pixels in scanners, digital cameras, monitors and printers. Although the term "pixels" is often used with regard to these devices, it is best to use "sensors" or

"dots." Usually scanners and digital cameras produce 1 pixel for each sensor, but not always. And usually printers print many dots for each pixel. The following examples illustrate these phenomena. Since a typical scanner might have 3000 dots (or sensors) per inch, scanning a 1" × 1½" piece of film produces a digital image of 3000 × 4500 pixels. Similarly, a printer doesn't print with pixels, but rather converts pixels into ink dots that are sprayed onto the paper. Almost always there are significantly more ink dots printed per digital image pixel. Thus a printer with a resolution of 2880 dots per inch (dpi) prints an image with only 300 pixels per inch (ppi). In reality, the term "pixels" is commonly used for the sensors of a wide number of devices. I can't change the usage of this word completely, but remember there is a difference between the computer term "pixel" and the scanners and cameras term "sensors."

 Pixels are not the same as Dots and Sensors Even though pixels are commonly used to describe the sensors of cameras or the output of printers, pixels actually only exist within a computer.

Resolution

Resolution is key to the transformation of digital images into printed images. It maps virtual pixels into the physical dimensions of inches. (My apologies to those of you living outside the USA.)

So far, pixels are just colored squares stored within a computer. But in effect the objective is to transform a physical image into a digital image and back into a physical image (i.e., take a piece of slide film, scan it into the computer creating a digital image, edit the digital image, and print it back out to paper).

It's important to note that resolution changes can scale one digital image into many different sizes. For example, the right resolution maps our 3000 × 4500 pixels image to a size of 30" × 45" at 100 ppi, or to a size of 10" × 15" at 300 ppi. Resolution is further complicated by the difference between dots and pixels. Typically, scanners produce an image with one pixel for each dot in the scanner sensor. But, as noted previously, printers almost always print with many more dots than pixels; often 6, 8 or more dots print for each pixel in the digital image.

Here's a concrete example demonstrating the transformation of a piece of 35 mm film to a larger printed image:

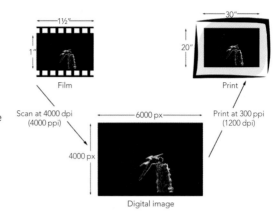

Film

Print

Digital image

The 35 mm film has an image area of about 1" × 1½". My scanner scans at 3000 dpi and produces a file with 3000 ppi, that's one pixel for each dot/sensor. 1" × 1½" at 3000 ppi produces a file of 3000 × 4500 pixels.

Once this file is in Photoshop, I can edit it without regard to the resolution, it is always a 3000 × 4500 pixel image.

To print a 10" × 15" image, change the image resolution to the printer resolution of 300 ppi, a typical printer resolution. The image is still 3000 × 4500 pixels, even though the printer might print at 1200 dpi (here four dots for each pixel).

Resampling/Interpolation

But what if I want to print an image that is 4" × 6" instead of 10" × 15"? By changing the digital image size to 1200 × 1800 pixels, the image prints at 4" × 6" at 300 ppi. Changing the actual number of pixels of a digital image size causes Photoshop to *resample* (or *interpolate*) the image. Or in other words, Photoshop takes the existing pixel information and estimates the appropriate pixel colors for the same image with the new image size. **Interpolation is a good thing**; it makes it possible to change the size of the image from various source sizes (different film sizes, different scanners, or different digital cameras) to various output sizes (different print sizes, different printers, or the web). Photoshop is generally very good at interpolating digital images.

Native Resolution

Often when I discuss interpolation, many people suggest that they can avoid interpolation merely by changing the scanning resolution and/or the printing

resolution. For the 3000 × 4500 pixel example, couldn't I also change the print resolution to 750 ppi if I wish to print a 4" × 6" image? The math is correct, but most digital imaging devices (like scanners and printers) only operate at a single fixed resolution, their native resolution. For scanners, the native resolution is based on the number of actual dots in the scanner. A typical film scanner has a 1" wide sensor with 3000 actual dots for measuring light across the sensor. The software for most scanners allows you to set the resolution to any value. But the scanner merely scans at its native resolution and then interpolates to the resolution you set. Similarly, most printers only print at a resolution of 300 ppi. But if you send them a digital image at a different resolution, the printer software will interpolate to 300 ppi. In almost all cases, Photoshop does a better job of performing this interpolation. **Don't interpolate in the scanner or printer software, do it in Photoshop.**

Many professional scanner or printer operators disagree and say you should scan at the specific resolution for the target print or you send a file with any resolution to the printer. In the case of very expensive scanners or very expensive printers (in the $100,000 range), this is true, the issues of native resolution don't apply rigidly. But the vast majority of desktop scanning and printing devices have a single native resolution.

Files for Digital Imaging

Photoshop supports a wide variety of file formats. But 99% of your image editing work will be completed with the formats described below. Most of the other formats are either outdated or of little interest to photographers. You can select the format for your image file by selecting **File>Save As** and selecting the file format from the Format option.

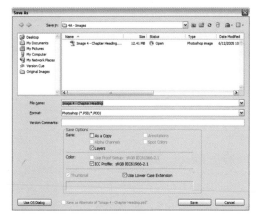

Photoshop (*.PSD)

Photoshop Standard Document (PSD) is the standard file format for Photoshop. It stores all of the information for a Photoshop image, including Channels, Layers, Selections, and File Configuration. It's important to save a version of your image as a Photoshop file with all this extra information so you can retrieve it all when you open the file later. **You should save all of your working files in this format**. Only Photoshop (or other Adobe software) can read Photoshop files. Save your images in TIFF format if you wish to take them to another program or give them to someone else.

Photoshop CS and CS2 have modified the PSD format to make the files smaller by eliminating a composite version of the image from the file. But some early version of Photoshop (version 4.0 and earlier) and some non-Adobe applications that read PSD files cannot use these modified PSD files. When saving Photoshop PSD files, Photoshop will provide you with a Maximize Compatibility option dialog. If you only intend on using these files within Photoshop, turn off Maximize Compatibility. This can be set in the Photoshop File Handling Preferences.

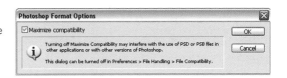

Photoshop PSD files can only support files up to 2 GB is size. For the majority of images, this is sufficient. But in the real world of digital imaging, it is possible to have larger files. Photoshop CS and CS2 support larger files by using the Large Document Format (PSB). This format supports all of the features of PSD files, but also supports files of any size.

TIFF (*.TIF, *.TIFF)

TIFF is the industry standard image file format. In many ways, a basic TIFF is just a big array of pixels stored in a large file. It doesn't contain much of the sophisticated information used

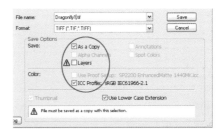

in Photoshop (especially Layers). TIFFs do contain color space information which is important for color management. TIFFs are a very safe way to save your image files since the image is saved in a loss-less state i.e., there's no data conversion caused by image file compression. **Use TIFFs any time a file is used outside of Photoshop**. TIFFs support both 8 bits and 16 bits per channel images.

Adobe has added a new wrinkle to TIFF, saving layers. As far as I know, this extended version of TIFF is only supported by Adobe. I recommend saving any TIFFs without layers.

One TIFF option allows compression of TIFF files. Use this option rather than image compression for TIFFs to ensure maximum compatibility with other programs and systems. The other TIFF options aren't very important and should be left unchanged.

JPEG (*.JPG, *.JPEG)

This is the format for compressed files. Most images on the Internet are saved in JPEG format, since they can be compressed to such smaller file sizes, at least 20:1 with little loss in image quality. Compressions of 100:1 are possible, but result in some significant loss in image quality.

All digital cameras have the option to save images as JPEG files so you can save many more images onto your camera's data card. But since this format only supports 8 bits per channel images, avoid using it for capture. But if your camera only supports the JPEG format, it's still workable.

Compression works best for smoothly toned images. Busy complex images do not compress well or lose detail if compressed. Keep this in mind when saving in this format.

JPEG files are good for use with the Internet. Within Photoshop use JPEG for images to save to the Internet or e-mail to someone over the Internet.

The JPEG Options dialog appears after you save you image. Set Image Quality to 9, "High" for most files and to, 6 "Medium" for especially large files or relatively unimportant files.

JPEG Format Options should be set to Baseline for most images.

PDF Files

Photoshop has excellent support for Portable Document Format (PDF) files. These files can be viewed by anyone using the Adobe® Reader. Since the Adobe Reader is almost universally available, PDF files are an excellent way to send very high-quality versions of your files to someone who may have access to Photoshop or even a modest image viewing program. This is an excellent format for sending high-quality proof images to others.

RAW Files

Many digital cameras can also save their images as RAW files. These are unprocessed digital camera images. Photoshop can process them to a higher-quality image than JPEG files. One of the biggest advantages of RAW files is they have more that 8 bits per channel of information and can, therefore, be edited more than JPEG files. Every camera manufacturer has its own proprietary RAW file format, the term RAW refers to a category of file formats. It encompasses a wide range of formats include NEF (Nikon RAW), CRW (Canon), as well as many other formats. Adobe Photoshop CS2 supports most RAW file formats.

CHAPTER 3
THE IMAGE
EDITING
WORKFLOW

I strongly recommend starting out with a well-defined workflow for editing digital images in Photoshop. Since Photoshop has so many different options, it's almost impossible to keep track of how to perform all of them. The workflow structure helps you tighten your focus on key tasks during each individual stage as you move through the editing process. Even after working with Photoshop for many years, I use this workflow to help me organize my editing process.

The Workflow Outline

The complete workflow has dozens of different tasks. To simplify I've broken the overall workflow into a series of stages. Each major workflow stage has about three to six tasks within it, but most can be performed easily in a few minutes. Each major stage also has its own section. This chapter covers in detail the stages "Organize the images" through "Performing Local Adjustments." "Photographic Edits" is covered in Chapter 5, Advanced Options , and "Print Preparation" and "Print" are covered in Chapter 4, Printing. The series of stages are:

- Capture the Image

- Organize the Images

- Open Image Files (Process RAW Files)

- Image Clean-Up

- Perform Global Adjustments

- Perform Local Adjustments

- Photographic Edits

- Print Preparation

- Print (or save for Web)

Let's begin with a brief summary of each stage.

Workflow Stage Summaries

Stage 0: Capture the Image

This is a book about Photoshop, not photography. I don't cover the specifics of digital image capture, but there are a couple points to make about the importance of image capture. First, ensure good exposure in your images. There's a myth that Photoshop can fix any type of problem in digital images. There are definitely many options for fixing problem images in Photoshop, but it's always best to start with a good image. Second, capture a sharp, straight image. Use sharp lenses and limit the use of camera filters or other light modifying tricks. Many filter effects are easily mimicked by Photoshop and with more precision.

Stage 1: Organize the Images

Create a strategy for keeping your images organized. I outline my strategy for creating separate folder trees for original images, images in process, and finished images. Moving your images through these folder trees makes it easier to find individual images. Also create various file as you move through the workflow to hold different versions of your images.

Stage 2: Open Image Files (Process RAW Files)

If you're new to digital photography and image editing, your camera is probably set to capture Jpeg files. If setting your camera to capture RAW files sounds like a new and complex idea, don't worry about doing that now. But once you're more comfortable working with your camera, you should try to set it to capture RAW files. Processing RAW files in Photoshop is covered in the "Processing RAW Images" section. If you continue to work with film (I shot most of the chapter images in this book on film), you'll need to scan your images into the computer to perform some basic processing steps on them. These steps are covered in the document "Working with Film" found on the website.

Stage 3: Image Clean-Up

Do basic image clean-up before doing any other edits. Get this stage out of the way so you won't have to deal with it over and over again. The three basic

clean-up elements are: straightening and cropping, spotting (or de-spotting, i.e., removing dust spots), and noise reduction.

Stage 4: Perform Global Adjustments

Global adjustments are individual adjustments to tone, brightness, contrast, and color that affect the entire image. If performed well, you can do 90% of the image editing work with a few simple, global adjustments. The section "Global Adjustments" uses the basic adjustment tools described in Chapter 2, Foundations. Chapter 5, Advanced Options, includes advanced adjustment techniques that can be performed globally.

Stage 5: Perform Local Adjustments

Sometimes you'll want to perform adjustments on only a portion of your image, say the sky or a person's face. In order to localize these adjustments to part of an image, you'll first need to create a selection for the part of the image you want to affect and then perform one of the basic adjustments. You merely need to get comfortable with making selections to perform local adjustments.

Stage 6: Photographic Edits

This is a catchall step for all the various types of image effects you might want to employ. Steps like adding soft focus, burning in and defocusing the image corners, blurring the background, adding film grain, and adding borders. Most of these techniques are best left after image adjustments. Some example techniques are listed in Chapter 5, Advanced Options.

Stage 7: Print Preparation

The last few steps are specific to the particular print size and the printer. They include final image cropping, final print resizing, and sharpening.

Stage 8: Print

Finally, print. Most inkjet printers today can make very good photographic prints right out of the box. Photoshop also allows many desktop printers to print using

profiles. Profiles improve printer color accuracy. Finally, you can print using an Internet printing service. These print techniques are covered in Chapter 4, Printing.

The various stages each limit the number and type of tasks that you perform on an image at one time. This simplifies the overall editing process, making it easier to progress quickly through each image. Now let's really bite the bullet on these stages!

Stage 1: Organizing the Images

One of the principle problems of working with digital images is organization. How do you keep your images where you can find them? Sadly, I'm not likely to win any awards for organization. But many of my students have had success by mimicking my basic system for organization. Although there are many possible systems, I offer mine with a few basic rules and as a place to start.

My system for organizing files requires:

- Move original files from the camera to the computer into an original images folder hierarchy.

- Store the original files in folders in chronologic order.

- Rename the original files to something useful.

- Sort through the original files for the best images.

- Copy these best images into a working images hierarchy.

- Edit the best images in their own directory, this is where the real editing takes place.

- Keep the original file intact, save versions of the cleaned file, edited files, and various printed or output files.

- Move the finished images into a finished images hierarchy.

- Sort the finished images by project.

- Move images off the computer into an archive.

Much of this organizing takes place within Adobe® Bridge®, a file management and browsing program included with Photoshop CS2.

Organizing Original Image Files

Most users will be using digital cameras for capturing their images, resulting in a large number of original files. **Save all your original files.** (Users working with film can organize with physical storage files. Refer to the web site for my comments on film).

You can do much of the image organization within your computer's file system, but for these examples, use Adobe Bridge. In many ways, Adobe Bridge works as both a traditional folder view on your computer and as a file management tool. Launch Adobe Bridge either by running the application separately or by selecting **File>Browse...** in Photoshop.

Adobe Bridge provides a pane for "Favorite" folders. Move your folder for holding your original images into this pane by dragging the folder into the Favorites pane. You can drag folders and files between Bridge and your computer folder system.

Create a folder tree for your original image files. Base the hierarchy for this tree on the date images were created. This makes it easier to add new image folders, and "date" is a reasonable structure for searching these original images. My folder tree includes levels for years,

My hierarchy for original images

months, and individual folders for projects within a month. Using this hierarchy, it's fairly easy to find original files even years after capturing them.

When you have captured the images for a particular project, create a folder within your original images tree for this project, including the date in the folder name. Copy your original, unedited image files into this folder.

Now you can look through thumbnails of your images in Bridge. This is especially useful for images shot as RAW files with your digital camera since RAW files are usually not visible in a typical folder tool. The thumbnails can be resized by dragging the thumbnail slider at the bottom of the thumbnail window in Bridge, allowing for easy previewing of the images.

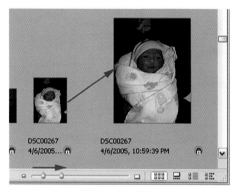

Change the thumbnail size

Rename the image files to something useful. Within Bridge, select all of the image files in the folder, select **Edit>Select All...**, and select **Tools>Batch Rename...**

Batch rename tool

Create a naming convention that works well for you. I typically include text in the filenames that refers to the general category of the images plus a sequence

number for each of the images. This makes it easy to identify a single image from a photography project. I usually also add "NEW" to my original image files to identify them as unedited files. Rename all of the images, not just the images you want to edit. And remember to keep all of the images, including the bad ones.

Sorting Original Images

Once the images have been renamed, identify all the images that are "Keepers." Go through all of the images in the project folder, select each good image, and assign a star value by selecting the **Label** menu. (The simplest model just

identifies good images as keepers, but you may choose to create a more complex system for image quality.)

Once you have selected the keepers, make them visible and hide the others by selecting the "Filtered" button and selecting "Show 1 or more stars" to display only the

good images. If an image is rotated improperly, select it and click on one of the rotate buttons in Bridge.

If you've only a few images to edit, make each filename more descriptive by clicking on the file name and adding some new text.

It's good to assign keywords to the images by selecting an image (or several images) and using the keyword panel. Assigning keywords is easy – determining

and using an appropriate keyword hierarchy is more challenging and beyond the scope of this book.

Organizing Edit Images

Up to this point, you've only been organizing original images. **Keep your original images unedited** so you'll always have an unedited version. Create another file tree for editing images. I call mine "Working Images" with folders for all the images I edit under it. I typically place each image into its own folder for editing, but it's also good to place several images for a single project within a single folder, especially if you intend on working on all these images together. **Copy** the original file(s) you want to edit into the appropriate folder(s) in your editing images tree.

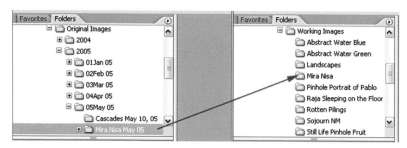

Copy the original files to a new directory for editing

In the editing folder you're now able to save several versions of each image. These versions include:

- A Clean version (created during the image clean-up stage)

- An Edit version (created during the image editing stages)

- One or more Print versions (created during the print prep stage)

- One or more Web versions

All of these versions are important files to keep. The clean version is a good starting point for editing any image, especially if you choose to go back and restart the editing stages on an image. The Edit version is important if you want to continue editing or rework a particular edit on your image. Edit versions are in

Photoshop format and include all of the layers you create to edit the image. The Print and Web versions are completed images and are useful if you wish to quickly open a file merely to make a quick print, or use an image on the web. Print and Web versions are usually flattened TIF or Jpeg files that can be used by other programs and users.

Open a file from within your edit folder to begin editing in Photoshop. For most file formats the image opens right up in Photoshop; this includes Jpeg files from digital cameras and Tiff files for images scanned from film. If the image is a RAW file from a digital camera, then Photoshop opens the files using Adobe Camera RAW. (More on Camera RAW in the next section.)

As you proceed through the workflow, I identify good spots to save Clean, Edit, Print or Web image versions. Be careful to save each version.

Archiving Files

As you complete the edit work on images, move them out of the "Working Images" directory or it'll quickly become a mess. I have a file tree for Finished projects. Each project has its own folder, and completed images are stored under the project folder. Keep the Clean file, Edit file, and appropriate Print or Web file for every image. It might be necessary to return to them in the future. If you want to edit the image again from the start, use the Clean file; make minor changes to the image edit, the Edit file; quickly make a print, the Print file; or move the file to the web, the Web file.

Eventually, you'll find your hard drive filling up with images under the Original Images folder, the Working Images folder, and the Finished projects folder. Don't just buy a bigger hard drive; you'll just fill it up, too. Determine a mode for storing extra files *off* your computer. Unfortunately, there is really no great way to archive large amounts of digital imaging data. But the powers that be in the computer industry are working to improve this. For now, though, one mode of archiving is with CDs or DVDs. But take care to select only *archival* CDs or DVDs and to store them in a protected environment, for example away from light. Also, be advised that archiving with CDs or DVDs consumes lots of time and disks. Another mode of archiving is onto removable hard drives. But hard drive data is not archival; and if left unused for many years, can be corrupted.

Stage 2A: Opening Image Files

Open an image file by double-clicking on an image in Bridge or by navigating through the File Open dialog within Photoshop.

Your image files will likely be in one of three common formats: TIF, Jpeg, or RAW. Images in TIF or Jpeg format open immediately and display in an image window in Photoshop. If Photoshop displays a Profile Mismatch warning, just click OK to dismiss the dialog. More on profiles in Chapter 4, Printing.

TIF files are common for images created from scanned film. See the web site for more on working with film.

Digital cameras usually create Jpeg files. The digital imaging community often dismisses Jpeg images as poor quality. But digital cameras are capable of producing excellent quality Jpeg images. **If your digital camera only creates Jpeg files, you still can create good images**. The main disadvantage of Jpeg images is their availability only in 8 bits per channel and consequent susceptibility to posterization or other forms of degradation when edited. Jpeg files are fine for minor image edits and excellent for E-mail and posting on the Web.

If you're opening TIF or Jpeg files skip over the next section on Processing RAW Images.

Stage 2B: Processing RAW Images

Many higher end digital cameras create RAW files. Each digital camera has its own RAW file format and file extension: Canon RAW files are called CRW files, Nikon files NEF, etc. RAW file images contain all the original data captured by the digital camera sensor. Working from this original data, the RAW file can produce a higher quality image than that created in a Jpeg image. **The main advantage of RAW files is their inclusion of data for 16 bits per channel images** and less susceptibility to image degradation under significant edit. One disadvantage is RAW files are much larger than Jpeg files, so you can store far fewer RAW images in your camera. And only a few applications, Adobe Photoshop CS2 and Adobe Bridge among them, can view them.

That said, it's best to capture digital camera images using RAW files. If you are new to digital imaging, capture your images as Jpeg files until you feel comfortable with the overall process. When you're ready, configure your digital camera to include capturing image as RAW files.

Open RAW files the same as other types of image files, by double-clicking on an image in Bridge or by navigating through the File Open dialog within Photoshop. When an RAW file opens, Photoshop displays the Adobe Camera RAW dialog.

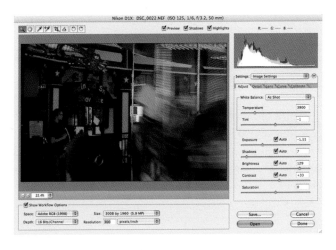

Adobe Camera RAW

Adobe Camera RAW integrates RAW files with Photoshop easily and provides a simple integrated interface for basic adjustments before opening them in Photoshop. These features make Adobe Camera RAW one of the best RAW utilities available. Camera RAW supports most digital camera RAW file formats. Check Adobe's web site to confirm support for any particular camera. (A search on the site for "Camera RAW" yields the appropriate page.) Adobe has done a good job of keeping Camera RAW up to date as new cameras (and RAW formats) are released. Newer cameras may require that you download a newer version of the Camera RAW utility from the Adobe web site.

Camera RAW provides some very rich options for editing that quickly generate very good looking images. Use Camera RAW for quick processing and leave

fine-tuning in the Photoshop workflow. The Photoshop workflow allows for more precision and fine-tuning work using layers. The default settings for Camera RAW are a good place to start.

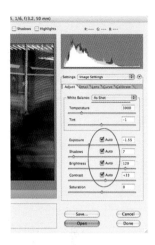

The default settings for Exposure, Shadows, Brightness and Contrast controls are all set to "Auto." For many images the Auto values work very well. Change these controls to adjust overall image density. Change the Brightness control for small overall brightness adjustments to the image. Exposure and Shadows act similarly to the black and white point sliders in the Levels tool. And Contrast will add contrast by spreading out the images histogram.

The White Balance control sets the overall color balance of the image. The default As Shot setting uses the control values set in the camera when the image was shot. Often As Shot values work just fine. But if the image color seems off, try adjusting the Temperature. The Temperature control makes the image appear warmer (more yellow) or cooler (more blue). The Tint control makes the image appear more green or more magenta and is difficult to use as a color balance tool.

It's important to set the appropriate Workflow options in Camera RAW. Set the Space option to match the default color space set in Photoshop (see Color Space on page 105). Set the Depth option to 16 bits per channel. And the Resolution options to the default resolution for your typical output option: 300 pixels per inch for most print devices, 240 pixels per inch for Epson inkjet printers, 72 pixels per inch for web images.

Camera RAW sets the Size option to match the default resolution for the digital camera. Other size options are available. An asterisk (*) option in the

size menu identifies a high quality option for upsizing images for some cameras.

Once you set the Exposure, White Balance and Workflow options, click on Open to process the image and open it in Photoshop.

Photoshop displays the name of the opened RAW file in the title bar of the image window, but Photoshop is actually displaying a version of the RAW file as processed by Camera RAW. If you try to save this image, Photoshop displays the Save As dialog and forces you to save a new file different from the original RAW file. You just cannot open and save RAW files.

 Use Camera RAW to process your RAW files. It's effective and easy to use. Use the default settings in Camera RAW as a starting point for most of your images. Make sure "Depth" is set to 16 bits per channel in Workspace options. Once opened, you cannot save RAW files *per se*. You can only save opened RAW images as new files.

Using Camera RAW with Multiple Images

Camera RAW can apply the same settings to multiple images. This is especially useful for images shot under similar lighting conditions and intended to display together. Images processed together show some variation in lighting, but appear to come from the same scene. Obviously, processing multiple images together speeds up the work.

To open multiple images in Camera RAW:

1	In Bridge, select multiple RAW image files and double-click on one of the images. Select images shot under the same or similar lighting conditions. Or in Photoshop, select multiple RAW images using the File Open dialog. Photoshop displays the Camera RAW dialog with a filmstrip along the left side of all the selected files.

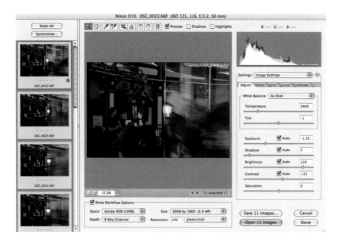

2 Click in the Select All button at the top of the filmstrip to select all the images.

3 Make adjustments to the Exposure, White Balance and WorkflowSpace options as you would for one image. Evaluate the top image as you make these adjustments.

4 Once the top image appears accurate, select the individual images in the filmstrip to inspect the effect of these setting on each image. Make small adjustments to each image as necessary.

5 Click on "Open xx Images" to process and open all of the images in Photoshop. It can take some time to open several images.

Or, click on "Save xx Images" to process each image and save them back to the same folder. Since you cannot save a processed RAW file, save them in another file format; TIF is a good choice. If there are many images to process, save the image files in the background.

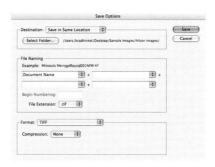

Open the first processed image and begin working as soon as it's saved back to the folder.

Stage 3: Image Clean-Up

As soon as you open your image, clean it up. This involves any obvious straightening and cropping, and dust and noise removal.

Many Photoshop power users recommend doing most of the clean-up at the end of image editing (in the print prep section). They argue that spots and noise may be more or less visible after significant editing. I understand this point, but I find them easier to spot right away. Plus having a clean starting image means I only have to spot it once, even if I end up using it in several different projects.

Outline of Image Clean-Up Tasks

Some image clean-up tasks aren't necessary for every image. Evaluate your need with regard to each particular image:

- *Straighten*: Rotate the image to straighten it.

- *Crop*: Crop out what is unnecessary (like the edge of scanned film, or a distracting object). You can crop again before your print.

- *Spot*: Remove any dust spots from the image.

- *Reduce Noise*: Reduce the digital camera noise in the image.

Straighten

If an image needs straightening, do it before you crop since you'll need to eliminate the white border created by the image rotation.

Use the Measure tool to straighten an image. It lets you draw a line along something in the image you want horizontal or vertical (like the horizon line or a building), and then rotates the canvas so the drawn line becomes horizontal or vertical. The steps are:

1 Select the Measure tool. It's the little ruler hidden under the Eyedropper tool in the toolbox.

2 Draw a line using the Measure tool along something in the image that should be horizontal or vertical. (Here I drew a line along the horizon.)

3 Select **Image>Rotate Canvas>Arbitrary** and select the value in the dialog. This value is the amount the drawn line is off horizontally or vertically. Click on OK to straighten the image. Remove the resulting white background when you crop.

Crop

Use the Crop tool for very precise cropping. It lets you zoom in for careful adjustments and creates a good preview before the final crop.

Select the Crop tool. Enter a specific Width and Height on the options bar, if you know the exact size for the final image. If needed, clear the options by clicking the Clear button. Leaving the Width and Height clear allow for an image of any size or shape.

Use the Crop tool to select a portion of your image. But don't be too precise here, just get the crop onto the image. Once selected,

adjust the selection size by grabbing a handle on the corner or edges of the selection.

Zoom in and out of the image while cropping to ensure the crop is exact. (Use the View Menu or Zoom accelerators in Chapter 2, Foundation.)

Once you've drawn a selection with Crop, the option bar changes. Before accepting the final crop, change the Opacity of the Shield from 75% to 100%. This completely blocks the pixels to be removed by the crop and provides a precise preview. Return the Opacity to 75%.

Press the Enter/Return key to crop.

Spot

There are two tools for spot removal I employ: the Spot Healing Brush and the Clone Stamp.

The Spot Healing Brush

The Spot Healing Brush is an improved version of the Healing Brush found in earlier versions of Photoshop. It works by merely clicking on a dust spot or defect in the image as follows:

1 Change the view of your image to 100% – select **View>Actual Pixels**. Zooming into 100% makes it easier to see dust spots and defects you might

otherwise miss. Select the Navigator Palette and move the view so it occupies the upper left of your image. Use the Navigator to move carefully over the entire image as you look for defects.

2 Select the Spot Healing Brush and move it over a dust spot on the image. Resize it using the [or] keys so it's slightly bigger than the defect.

3 Click on the defect, and Photoshop eliminates it. Repeat across the entire image to delete all the dust spots.

It is that simple to use.

When cleaning up the image, look for dust spots or other obvious defects in your image and just spot them away. But don't use this tool to fix blemishes in portraits or remove distracting objects from the image. It is best to fix these problems using a separate layer.

The Spot Healing Brush has several options. Keep the detail Mode set to Normal and the default Type set to Proximity Match.

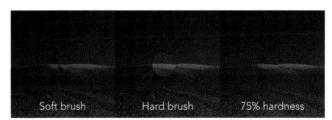

Soft brush Hard brush 75% hardness

The Spot Healing Brush works best with a moderately hard-edged brush; a very soft-edged brush doesn't completely fix a defect, and a very hard-edged brush can leave a noticeable edge around the defect. Open up the Brush options and change Hardness to 75%.

Dust at a edge Smudge Re-Do

Sometimes the Spot Healing Brush just fails and creates an obnoxious smudge. This is especially common if the dust spot is right at the edge of an image. If this happens, press ⌘ / ctrl +Z, and just try the brush again. This often fixes the problem. But if you can't get a good result with the Spot Healing Brush, use the Clone Stamp tool as a back up.

The Clone Stamp Tool

Use the Clone Stamp tool to copy a piece of your image and stamp it onto another area of the image. If the intelligence of the Spot Healing Brush fails, carefully determine if the stamp can fix the defect.

First find a spot on the image and an adjacent area of the image without the spot but with a similar texture. You'll clone from the "clean" area onto the spot.

Select a brush with a hardness of 75% and make the brush slightly larger than the defect.

Place the pointer over the "clean" area of the image. It appears as a circle the same size as the selected brush. Hold down the alt / ⌥ key to display a small target and click on the clean area.

Once you selected a "clean" area, release the alt / ⌥ key, move the mouse over the top of the spot to be removed, and click over the spot.

Repeat for each spot.

When you click over a spot, the Clone Stamp tool also displays a cross over the clone capture area. Keep track of where the clone comes from to ensure it's still the correct tone to capture.

Keep adjusting the size of the tool to be slightly larger than the size of the spot to remove. This reduces the appearance of artifacts.

Don't drag the Clone Stamp tool around the image, rather make many different clicks to cover many spots or remove a scratch or dust streak. Dragging the brush over the image produces parallel patterns that are easily noticed.

Reduce Noise

Digital camera images all contain some amount of digital noise. The noise is just random density variations resulting in a random pattern of spots over the image. Although digital cameras have reduced noise dramatically, it's a good idea to run the noise reduction filter on most images anyway.

Select **Filter>Noise> Reduce Noise** to access the Reduce Noise dialog.

Turn off the Preview option in this dialog and look for digital noise. Digital camera noise is most noticeable in the smooth-toned areas of an image.

Turn the Preview option back on. For most images the Photoshop default settings for the Reduce Noise dialog are good. Increasing the strength may further reduce noise, but often it begins to soften the image. Don't increase the Sharpen Details option beyond 25% – you can sharpen the image later in the workflow.

The Reduce Noise filter works well for reducing typical noise in digital camera images. For images with significant levels of noise, more advanced techniques are required. Often, I end up masking the noise in very noisy images with some other effect such as film grain.

Save the Clean Image

Once you have completed the image clean-up stage, save a clean version of the image. Select **File>Save As...** for the Save As dialog to provide a new name and file format. Save the clean image as a Tif file, the image does not yet have any layers, so you can use this simpler format. I suggest including the text "Clean" in the file name so you can easily identify the stage for this image file.

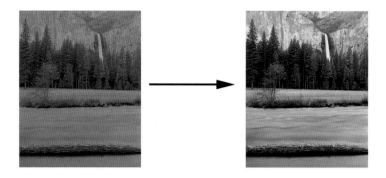

Stage 4: Perform Global Adjustments

Most users just want to open up an image and quickly perform some basic edits on the image to improve its contrast and color. The basic adjustment tools covered in Chapter 2, Foundation (Levels, Curves, Color Balance, Hue/Saturation) suffice for these edits on most images. This is the heart of editing images in Photoshop. **If you learn to perform these adjustment tasks well, you can do 90% of the work necessary to edit images well**. Perform these basic adjustment tasks first and as few other fancy edits as is possible.

Adjustments are simple operations on image pixels, e.g., making each pixel 10% darker, or adding 5 points of blue to each pixel. Some adjustments get significantly more complicated, but in general, adjustments are just pixel-by-pixel operations. Yet, most of the important work on your image results from these basic adjustments.

I like to compare these first basic tasks to creating a good straight print in the traditional darkroom. A good straight print has good density, good contrast, and good overall color.

Adjustments Tasks and Adjustment Tools

Often the appropriate tool for a specific adjustment is not that obvious. For example, the Brightness/Contrast adjustment tool is usually poor for adjusting brightness or contrast. Instead, for adjusting brightness, use the Levels tool; for adjusting contrast, the Curves tool. Why? Because the Brightness/Contrast tool adds brightness or contrast to every pixel uniformly – the same amount to

highlight, midtone, and shadow pixels – resulting in a very unnatural looking change in brightness or contrast.

For this reason, I emphasize: **The syntax of the task doesn't necessarily correlate with the syntax of the tool**. Determine the adjustment task you want and then pick the appropriate tool. Often there's more than one tool for each adjustment. Here are the common adjustment tasks and some tools used to perform each:

Adjustment Tasks	Adjustment Tools
Black and White Points	Levels Tool
Brightness	Levels Tool
	Curves Tool
Contrast	Curves Tool
	Contrast Mask
Highlights/Shadows	Curves Tool
	Shadow/Highlight Tool
Color Balance	Color Balance Tool
	Auto Color/Curves Tool
	Levels Tool
Edit Color	Hue/Saturation Tool

There are more tool options for these basic adjustments, but these are the main ones and the ones covered in this book. Separating the tools listed in Photoshop from the task you want is confusing at first. Just keep in mind Photoshop lists only the tools.

Notice the Curves Tool can be used for just about every adjustment. It's the basic power tool in Photoshop. And remember: *Don't use the Brightness/Contrast Tool to edit Brightness or Contrast*.

Order of Adjustments

It's also important to perform adjustment tasks in a specific order: edit density first, then color balance, then individual color adjustments.

Black and White Points
Brightness
Contrast
Highlights/Shadows
} Density Adjustments

Color Balance
Edit Colors

 Some very good professionals suggest the first adjustment be color balance. I understand their arguments, but find it difficult to correct color balance without first correcting image density. This is a classic case of many ways to approach any problem in Photoshop. I present my method here, but keep an open mind to others as you learn more techniques.

Get the density right, then adjust the color.

Adjustment Layers

Apply all the basic adjustments described in this section using adjustment layers. **Apply adjustment layers rather than adjustments directly to the image. Select the Layer>New Adjustment Layer sub menu, *not* the Image Adjustments sub menu**.

When you first create an adjustment layer, Photoshop displays the New Layer dialog so you can name it. **Name layers based on the adjustment task to be performed**; e.g., "Black and White Point" or "Brightness." This makes it much easier to find the appropriate adjustment layer when editing the image at a later time. Once named, the appropriate adjustment dialog appears. Perform the adjustment task using the dialog. Clicking on OK creates the layer and applies the adjustment.

Review Adjustment Layers in Chapter 2, Foundation on page 20.

Black and White Point Adjustment (Levels Tool)

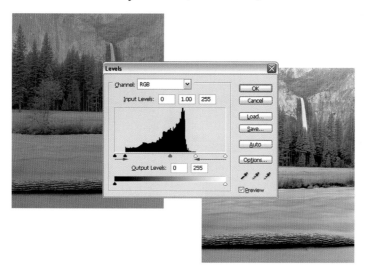

Most images look best printed to maximum contrast: full black to full white (or, perhaps, nearly black to nearly white to preserve detail). The first step for adjusting global image density is to ensure the image is adjusted to this maximum contrast.

Move the black point slider to the right until it is under the first few darkest pixels in the image. This makes these pixels pure black. Move the white point slider to the left until it is under the first few brightest pixels. This makes these pixels pure white. Many images need only a small amount of black and white point adjustment. This can be the most effective adjustment you perform.

More on the Levels tool in Chapter 2, Foundation (page 31). And more on black and white point adjustment in Chapter 5, Advanced Options (page 141).

Adjusting Image Brightness (Levels Tool)

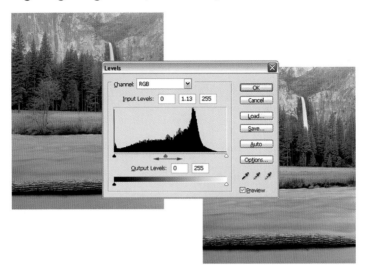

The Levels Adjustment tool provides an easy way to adjust the overall brightness of an image. And it does it without necessarily adjusting white or black point values. To make a brightness adjustment, open the Levels Adjustment dialog, and slide the center gray slider under the histogram.

Adjusting Image Contrast (Curves Tool)

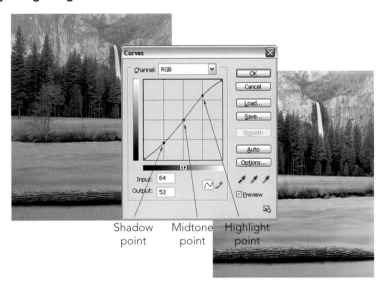

Shadow point Midtone point Highlight point

The Curves tool provides a good way to adjust global image contrast. It allows for increased contrast in localized image tones (e.g., the midtones). Increased contrast in the midtones flattens the highlights and shadows resulting in a global increase in image contrast.

In the Curves dialog, place a point near the shadow end of the curve and drag it down to decrease contrast in the shadows. Then place a point near the highlight end of the curve and drag it up. Last, place a point near the midtone and adjust it for best global tone. This produces a typical S-Curve.

An inverse S-Curve produces a flattening of overall image contrast.

More on Curves in Chapter 2, Foundation. More on editing contrast in Chapter 5, Advanced Options.

Adjusting Shadows/Highlights (Curves Tool)

Add three points to lock the middle of the curve

Adjust the shadow point

The Curves tool is also great for increasing the detail in highlights and shadows. It's best to perform this adjustment separate from using Curves to increase contrast, i.e., perform the separate adjustment tasks by creating two adjustment layers.

In the Curves dialog, first place a point at quarter tone, midtone, and three-quarter tone. This fixes the curve for most of the tonal image range and allows localized adjustment to the shadows only. Now place an additional point in the shadows and adjust it to bring out more detail.

Create a separate adjustment layer to add highlight details.

Options for using the Shadow/Highlight tool are in Chapter 5, Advanced Options (page 149).

Color Balance (Color Balance Tool)

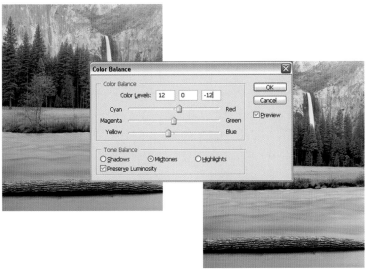

The Color Balance tool is adequate for making large global image adjustments, so go ahead and use it for Color Balance adjustment. Open the Color Balance dialog and adjust the color levels. Move the sliders for each color channel to get the image to a fairly neutral color balance. The Color Balance Tool only provides for basic control of global color balance. More details on the Color Balance Tool in Chapter 2, Foundation.

But the Color Balance tool isn't the best tool for performing a color balance adjustment. Most people use the Curves tool for color balance. But start working with the Color Balance tool; it's good for understanding the basic color model used in digital images. More options for performing a color balance adjustment in Chapter 5, Advanced Options.

Edit Colors (Hue/Saturation Tool)

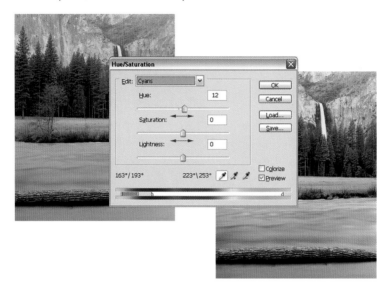

The Hue/Saturation tool provides some quick and easy steps to add some "snap" to your image. It also provides some precise control over editing individual image colors.

In the Hue/Saturation dialog, choose a color in the Edit list box to localize edits to a specific color range. (The default "Master" edits all color ranges.) The Hue option shifts the color range towards its adjacent colors, that is blue colors shift towards cyan or magenta. This is especially useful for color shifts localized in specific colors. You can also change the saturation of specific colors.

Change the Lightness option with care, as it affects global brightness and can turn pixels completely white or black (as in the Brightness/Contrast adjustment). More on the Hue/Saturation tool on in Chapter 2, Foundation (page 38).

The Success of Basic Adjustments

Open up a few images and create adjustment layers for each of the basic adjustments on each image. I try each of these basic adjustments on almost all of my images right away and, thereby, complete 90% of the important editing work right off the bat.

You'll learn a number of other techniques for some of these basic adjustments (especially for obtaining good color balance) and some more advanced options for the tools I've already described. But these basic tools are still very powerful options.

Now you've got a handle on the most important photography steps in Photoshop.

Stage 5: Perform Local Adjustments

In the preceding sections, all the adjustments were applied globally – affecting all image pixels. Yet, almost always you'll still want to apply some adjustments locally – affecting the pixels in only one image part or image "selection." But you can get lost in the techniques of making selections. You need to step back and start with a look at the overall process of localized adjustments. So this section starts with an ordered list of tasks on that process, followed by techniques for creating selections, notes on selections, and ending with the application of localized adjustments with layers and editing the mask.

A Task List for Localizing Adjustments

This task list is important; it shifts emphasis from specific techniques for making a selection to the overall process of localizing adjustments. The basic strategy is to determine the localized adjustment, create a good basic selection of the image area, feather this selection, create a new adjustment layer, make the adjustment, and fine-tune the mask.

Determine a Name for the Localized Adjustment

First clearly articulate what you're trying to do – this may sound trivial, but it's often the most important step. A well-articulated name identifies the steps for the localized adjustment. Some name examples for localized adjustments are:

- Darken the foreground

- Make the Sky Bluer

- Add contrast to the person

- Reduce the blue in the shadows.

All of these examples include a localized part of the image (foreground, sky, person, shadows) and a specific adjustment (darkens, make bluer, add contrast, reduce blue). Now you know what to select and the adjustment to perform on the selection. It's so much easier this way. You will also use the name for this localized adjustment when you create the adjustment layer later in this task list.

Make a Basic Selection

Once you've identified the image area to adjust, make a basic selection of this area. There are several good selection tools to use: the magic wand, the color range selector, the elliptical marquee, and the brightness selection. Use the best tool to make a basic selection, but the selection doesn't have to be perfect. Add to or subtract from the selection using the **Shift** or **alt** / ⌥ key, respectively, or Invert it using the Select Inverse command.

If none of the selection tools seem to work for you, try creating a simple selection using the quick mask. More on specific techniques for selections are discussed later in this section.

Edit the Selection/Feather the Selection

Often you'll make edits to the selection after first making the basic selection. Most often you'll feather the selection; use the Select Feather command. Feathering controls the appearance of the edge around the adjustment. For very sharp edged selections, feather by at least one or two pixel. For very soft-edged selections, feather by 20 or more pixels. When in doubt, feather more rather than less. Later, if needed, you can soften or harden the mask created from your selection.

Create an Adjustment Layer

Create a new adjustment layer by selecting **Layer>New Adjustment Layer> (any adjustment)**. Photoshop automatically creates a mask based on the selection you created. The mask makes the adjustment apply only in the area of the previous selection. Use the same name you determined for this localized adjustment to identify this new adjustment layer.

Some adjustments you might want to make (such as the Shadow/Highlight adjustment) are not available as adjustment layers. To perform these adjustments, first create a Merged Image Layer (see the section on Merged Image Layers in Chapter 2, Foundation). Photoshop doesn't automatically convert your selection to a mask when you create a Merged Image Layer. Do this by clicking on the add layer mask icon at the bottom of the layers palette.

Remember, again, to use the name you determined for this localized adjustment. Also, when you create the mask for the Merged Image Layer, Photoshop makes it active. Don't forget to make the image part of this layer active by clicking on the image in the layers palette. (Otherwise you'll be adjusting the mask!) You'll be using Merged Image Layers for a number of tasks in Chapter 5, Advanced Options.

Make the Adjustment

Make your adjustment within the specific adjustment dialog. Since the mask was created based on the selection you created, the adjustments are localized to the area you selected. Work with the adjustment until it provides the correct image. Don't worry if the area of the adjustment is not exactly correct at this point. It'll be good enough to visualize the adjustment. Once the adjustment is correct, click on OK to accept the adjustment.

If you created a Merged Image Layer, select the appropriate adjustment from the Image>Adjustment menu or the Filter menu and perform the adjustment.

Edit the Mask to Fine-Tune It

Now fine-tune the mask. There are several tools for editing the mask. If the layer is an adjustment layer, the mask is automatically selected for any edits. If the layer is a Merged Image Layer, you need to select the mask by clicking on it. The most common options for editing a mask are to paint on it using the paintbrush and to feather it by blurring with the Blur filter.

Repeat as Necessary for Other Localized Adjustments

Experiment with this task list. Take an image and perform some simple localized adjustments. Try "add contrast to the center of the image" and "darken the bottom half on the image." Use the simplest selection tools to start: the Elliptical and Rectangular Marquee tools work for these examples. Get used to this particular task list. It's the easiest way to work with selections and masks and works for the vast majority of localized adjustments.

Some of My Favorite Selections

Given the task list for localized adjustments, you need to familiarize yourself with selection techniques. Selections should be quick and easy; most should take less than 60s to create. Users often try way too hard to create a very precise selection. Even with the basic selections tools this can be very frustrating. There are definitely times when a very precise selection is needed. But most often a fairly simple selection is all that's needed.

Here are some of my favorite selection techniques. They're not listed in any particular order of preference, but more in an order of how I like to teach them. Try them all out. I use my image from Valley of Fire in Nevada in these examples, it seems to have characteristics appropriate to most of these techniques.

Magic Wand

The Magic Wand is a great tool for selecting large areas of the image fairly continuous tone. In my example, the sky is fairly easy to select with the Magic Wand. Just click in the open area of the sky to make a selection.

By default, the Magic Wand often won't select all the pixels you want. Here only part of the sky is selected. There are two important options for the Magic Wand you can change to affect how much is selected.

Tolerance determines the similarity of pixels to select. A lower value selects few pixels very similar to the pixel you click; a high value, more pixels. Generally, the default value of 32 is good. If too many pixels are selected, lower the tolerance, and try Magic Wand again. If not enough pixels are selected, don't raise the tolerance; it is easier to just extend (or add to) the selection. If you have made

a selection, and want to make it bigger, just hold down the **Shift** key and make a second selection – using the shift key adds the second selection to the first. **The Shift key is usually the easiest way to make an existing selection larger**. Four or five quick clicks usually suffice to make a good selection. There may be a few "spots" of

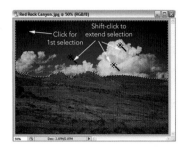

marching ants that are difficult to select, but don't worry about them. They might not make a difference to the edited image and are easy to fix when you edit the mask later in the process.

The Contiguous option sets Magic Wand to select only pixels in a contiguous field around the pixel you've clicked. This is useful for selecting a field of color in one part of the image. Turning off the Contiguous option selects pixels similar to the clicked pixel across the entire image.

The Sample All Layers option selects pixels based on the currently visible layers, i.e., what you see on the screen. Typically, I leave this option on.

Invert the Selection

It's often easier to select what you don't want selected than what you want selected. Just make a selection of everything that you don't want, and then invert the selection. Use the **Select>Inverse** menu command. In this example, it's easy to select the sky with Magic Wand and then invert the selection to make a selection of the foreground.

Elliptical Marquee Tool

The Elliptical Marquee tool is often maligned because of its simplicity. It's often easiest to make a very quick selection with a few clicks of this tool, feather this selection, and use this selection

to make a quick localize adjustment. A quick selection is often sufficient. For this example, I want to make a quick selection of the large white cloud in the image. Pick the elliptical selection tool from the toolbox. If Rectangular Marquee is displayed, click and hold the Rectangular Marquee tool to display the Elliptical Marquee tool underneath. (You can

also select the current Marquee tool by pressing the M key, and switching between the Rectangular and Elliptical Marquee tools by pressing `Shift` +M).

Make a few passes with the Elliptical Marquee over the image part you want to select while holding down the shift key to build up an irregular shaped selection quickly.

If you select too much of the image with the Elliptical Marquee undo the most recent selection easily by hitting `⌘` / `ctrl` +Z. Or subtract a piece from the current selection. To subtract from a current selection, hold down the `alt` / `⌥` key while making a selection over the part you want to remove from the selection. This is an easy way to take a quick bite out of an existing selection.

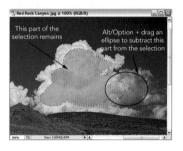

When making a selection using the Elliptical Marquee tool, you almost always want to feather the selection with a fairly large value to soften the edge of the selection. Make the edges soft enough and the irregular edges of the elliptical selection won't be visible in the final image. Remember, it's also possible to soften a selection further when you edit the

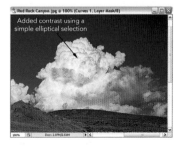

mask at the end. In this example, I added contrast to the cloud using a very simple Elliptical Marquee selection.

Feathering the Selection

Feathering the selection is a very important part of the selection process. Feathering the selection smoothes the transition between the adjusted and unadjusted portions of the image resulting in a more natural look. **In general, always feather the selection at least some**. Feather the selection by using the **Select>Feather...** menu command. Selections along a very well defined edge (like the transition from sky to foreground in the example) should be feathered slightly – use a value of 1–4 for the feather. Selections that are very irregular (like the one created using the Elliptical Marquee) should be feathered a lot – use a value of 20–40. Use larger values for larger images. Very large images (10 Megapixel and larger) often require much larger feathering values.

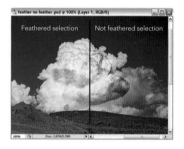

Feathering a selection makes some of the pixels along the edge of the selection "partially" selected. Partially selected pixels result in a mask with some intermediate (gray) value, neither completely masked (black) nor completely visible (white). Pixels that have a gray mask only have a portion of an adjustment applied. This provides for a range of pixels along the edge of the selection to display a smooth transition from the complete adjustment to no adjustment.

Don't worry too much about the exact value of the feather command. It's important to feather some so the process of making the adjustment is more accurate, but you can adjust the amount of the feather later when you edit the mask.

Painting a Selection Using Quick Mask Mode

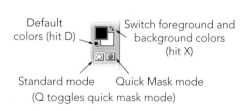

Default colors (hit D)

Switch foreground and background colors (hit X)

Standard mode Quick Mask mode
(Q toggles quick mask mode)

Quick Mask mode is an easy way to just paint a selection using the paintbrush tool. Quick Mask mode makes it possible to edit a selection as if it were an image using any of the image editing tools in Photoshop. We'll start with the paintbrush in this example and then use the gradient tool in the next example.

Turn on the Quick Mask mode by pressing the Q key. Turn it off by pressing the Q key again. You can also click on the Quick Mask mode buttons in the toolbox. Photoshop shows you're in Quick Mask mode by displaying "Quick Mask" in the image title bar.

Before you start painting, open the Quick Mask Options dialog by double-clicking on the Quick Mask mode button in the toolbox. The options dialog allows you to set the color for displaying the quick mask. Usually a bright red color works for most images. For this image, I want to change the color to something that will contrast with the red foreground. Double-click on the color square to bring up the color picker and pick a different color. I selected a dark green. Set the quick mask to show the selected areas. The colored area becomes the selection when you switch out of Quick Mask mode. Click on OK to close the Quick Mask Options dialog.

You can now use the paintbrush to paint onto the quick mask. Just select the Paint Brush tool, set the paint colors to the default colors (press D), and paint. Painting black grows the quick mask, painting white removes it. Press the X key to switch the foreground color from black to white. Use the square bracket keys ([or]) to make the brush larger or smaller. The mask shows up over the image as a semitransparent overlay. Once you have painted the selection you want, press the Q key again to switch out of Quick Mask mode and display your selection.

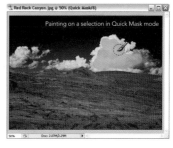

Be careful in Quick Mask mode. Quick Mask mode merely changes the selection into an image that overlays the main image. Most of the standard Photoshop tools still work in Quick Mask mode, including the selection tools, but this can cause some confusion about the current "state" of the selection in Photoshop. **It's usually best to switch to Quick Mask mode, paint the selection, and then switch right out of Quick Mask mode**.

Making a Gradient Selection using Quick Mask mode

A gradient selection lets you make an adjustment transition smoothly across part of the image. In my example, I want to make a selection that allows me to darken the bottom 1/3 of the red rock foreground. The gradient makes a smooth transition for this selection. For the gradient selection, just paint a gradient onto the quick mask.

Switch to Quick Mask mode (press Q). Open Quick Mask options dialog to ensure the color shows the selected areas and a useful color is selected.

Select Gradient tool on the toolbox; press the G key.

Use foreground to background colors

Create a linear gradient

Apply the gradient at 100% opacity using the normal blending mode

The default options for the Gradient tool are usually the best options. These paint a gradient using the foreground and background colors, create a linear gradient in the direction you paint, and apply paint to the gradient over the top of the quick mask. To paint the gradient, just draw a line in the direction you want the gradient – not along the edge of the gradient.

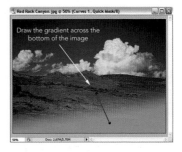

Don't worry, just draw a line. There's a good chance the gradient won't be at all what you expected. Often you'll paint the gradient in the wrong direction or paint a mask where you want no mask. If you get the wrong gradient, just draw the gradient again. Maybe switch the direction of your line. Experiment with the gradient until you get the quick mask

over the part of the image you want selected. This creates a selection over part of the image with a nice smooth transition to the unselected part. Switch out of Quick Mask mode to see the gradient selection.

Polygonal Lasso Tool

The Polygonal Lasso Tool is also an easy tool for making quick, rough selections of irregular shaped objects. You can then feather these selections to soften the roughness. I prefer the Polygonal Lasso tool over the traditional Lasso tool. you can use the Lasso tool to just draw a selection on the screen, but the Polygonal Lasso requires that you make a series of clicks to make a more precise selection. Pick the Polygonal Lasso tool from the toolbox. If the Lasso tool is displayed, click and hold the Lasso tool to display the Polygonal Lasso tool underneath. (You can also select the current Lasso tool by pressing the L key, and switch between the three Lasso tools by hitting `Shift`+L).

Use the Polygonal Lasso tool by clicking along the edge of the selection you want to make. If you come to the edge of the image, click outside of the image to select right along the edge of the selection. To complete the selection, make selection points until you get back to the first selection point and click back on the original point. Or you can double-click to automatically create a point

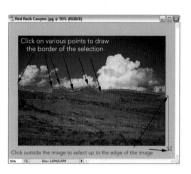

and connect it to the last point and close the selection. Again, remember, let this be a rough selection tool. Don't try too hard to make a perfect selection. And remember to feather the selection you created using the Polygonal Lasso tool.

Select Color Range: Highlights, Midtones, Shadows

The Select Color range tool lets you select various tones in your image based on the density. Selecting the Highlights selects the highlight pixels and also makes a gradient of pixels with a density between highlights and midtones. To make a quick density selection, use the **Select>Color Range...**

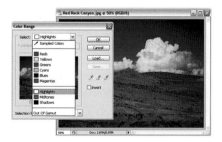

menu command to open the dialog. Open the Select dropdown to access the options for Highlights, Midtones, or Shadows.

Photoshop selects a predetermined range of tones for each of the selections for Highlights, Midtones, or Shadows. These often work well for making a quick selection, but sometimes you may want to select only the darkest shadows or a specific 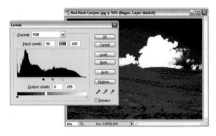 range of midtones. To access these tones, make a quick "bogus" adjustment layer to force Photoshop to select the tones you want Photoshop to select.

In this example, I created a "bogus" levels adjustment layer that makes the clouds well-defined highlights. It's then easy to use the Color Range tool to quickly select the highlights, then throw away the bogus layer, so that the well selected clouds remain.

Select Color Range: Sampled Colors

The Color Range tool is similar to the Magic Wand tool in that it selects a range of pixels by clicking on the image and Photoshop selects similar pixels. Open the Color Range dialog by using the **Select>Color Range** menu command. Create a selection based on a sampled color by clicking on a color in the image window.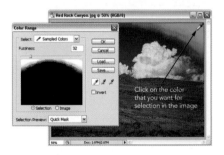

The window in the Color Range dialog displays a black and white version of the selection it creates. You can also display a quick mask over your image that shows the selection by changing Selection Preview to Quick Mask.

The Color Range tool has one significant advantage over the Magic Wand; it completely selects pixels that are very similar to the pixel you click on. Plus it

partially selects pixels that are less similar to the pixel you click on, thus providing a built-in feathering option based on the sampled colors. The Fuzziness slider lets you adjust how similar pixels must be to the selected pixel for these to be selected or partially selected, increasing the fuzziness results in a larger selection. The default value of 32 is good.

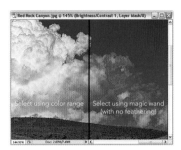

If the Color Range tool selects too many pixels, try reducing the fuzziness to reduce the number of selected pixels. If the Color Range tool selects too few pixels (very common), don't increase the fuzziness, but rather sample additional pixels by holding the Shift key and selecting more Pixels.

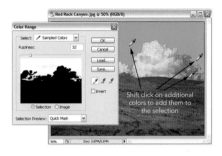

The Color Range tool selects all the pixels in the image that are similar to the sampled color. Restrict the area the Color Range tool uses by making a quick selection on the image before you activate the Color Range tool. In this example, I want to select the clouds on the left edge of my image. I first make a very quick selection around these clouds using a simple tool like the Polygonal Lasso.

When I open the Color Range tool, the selection is restricted to pixels inside of the first selections. I sampled cloud pixels and created a selection that only includes the clouds I wanted.

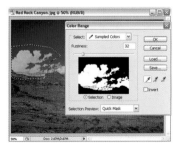

Magnetic Lasso Tool (?)

 The Magnetic Lasso tool is a "cool" tool that works wonders on images with very well defined edges but is amazingly frustrating on images with less than ideal edges. The Magnetic Lasso creates a selection along an edge with well-defined contrasts of color or density, so it works best where the edge contrasts are noticeably different in the image. Just select Magnetic Lasso from the toolbox, click at the edge you want selected to start the selection, and drag along the edge to create the selection.

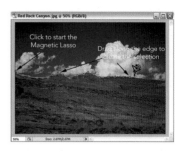

There is a good chance that Magnetic Lasso will jump off of the edge you want and move the selection somewhere else. Don't panic! Just move the pointer back to the edge you want selected and force Magnetic Lasso back to this edge by clicking on it again. Don't worry about the piece of the selection that is "off" the edge; you can clean this up later when you edit the mask.

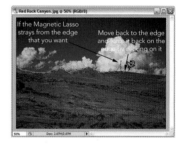

Some Notes on Selections

These are the selection tools I use most often. The best way to learn them is to experiment with them. Don't get stuck with one favorite tool. It might be great for some selections, and very difficult for others. Here are some additional reminders on creating selections:

Selections can be built by combining multiple selections It's often easiest to combine together multiple selections to create one larger selection. Hold down the shift key while making a new selection to add this new selection to the existing selection. Remember to build a selection rather than expect one tool to make a great selection in one quick step.

Take a chunk out of a selection by subtracting from a selection. Hold down the **alt** / ⌥ key while making a new selection to subtract this new selection from the existing selection. Use different tools to build up a selection from multiple pieces.

Imperfect selections Many of the tools make decent selections, but these might still have imperfections. It's common for the Magic Wand or Color Range tool to make a good selection, but leave small unselected spots within the field of color selected. Clean up many of these imperfections quickly and easily by using a paintbrush. Either go into Quick Mask mode from your selection and paint on the quick mask to clean up the selection or wait and clean up the mask created from the selection.

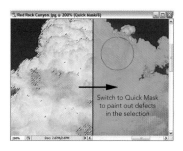

Switch to Quick Mask to paint out defects in the selection

Performing the Adjustments

Once you have the selection and have softened it some through feathering, immediately create the adjustment layer or merged image layer for your target adjustment. I often opine that selections have little purpose other that to be converted into a mask.

Create an adjustment layer and perform the specific adjustment you determined at the beginning of this process. Photoshop automatically converts the selection into a mask for this adjustment layer.

If you need to create a Merged Image layer (because the adjustment you want to perform is not available as an adjustment layer), first create the Merged Image layer. (Press ⌘ / ⌥ / **Shift** +E or **ctrl** / **alt** / **Shift** +E.) Convert the selection into a mask by clicking on the Add Layer Mask icon at the bottom of the layers palette, rename the Merged Image layer to the name you determined for this localized selection, select the Merged Image layer (Photoshop selected the mask when you created the layer mask), and finally perform the appropriate selection on the Merged Image layer.

The result should be an adjustment layer or image layer that contains the appropriate adjustment, and a mask that localizes this adjustment to a part of the image.

Editing the Mask

The final task for localizing adjustments is editing the mask. Often the mask is just fine for the adjustment you want, so you can just skip this step, but the mask might also be improved by some basic edits.

I have five basic edits for fine-tuning a mask: painting, blurring, sharpening, expanding, and contracting.

In my examples, I show the mask displayed along side the image as it is being edited. In most cases, you don't really need to see the mask as you edit it, but rather, look at the image. **The mask doesn't really matter, only the affect it has on the final image**.

Painting on the mask Make some simple changes to a mask just by painting on it. For adjustment layers, the layer mask automatically is selected for painting. For the image layer you first need to select the mask for painting. Just click on the mask in the layers palette to select it. (Otherwise you might paint on your image layer.) Photoshop shows the Layer Mask is selected by displaying Layer Mask in the image title bar.

Red Rock Canyon.jpg @ 50% (Add Contrast, Layer Mask/8)

Select the Paint Brush tool from the toolbox, set the foreground and background colors to the default values (white and black), and start painting. Painting black adds to the mask (hides the adjustment) and painting white removes the mask

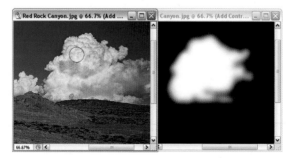

(reveals the adjustment). Change the size of the brush using the square bracket keys ([or]). Paint more softly by changing the opacity of the paintbrush to paint gray values on the mask. More details on painting in the section on the paintbrush in this chapter.

Blurring the mask Blurring the mask is similar to feathering the selection. Often the selection may not have been feathered sufficiently, or you may have painted the mask using a hard-edged brush. You'll be surprised how many carefully prepared images are improved by blurring the mask.

To blur a mask, simply select **Filter>Blur>Gaussian Blur** and adjust the radius of the blur. The filter previews the result of this edit.

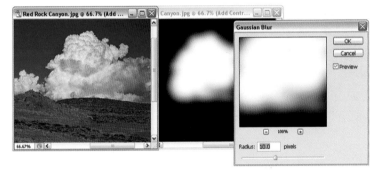

Sharpening the mask Finally a good reason to use the Brightness/Contrast Adjustment tool! Increasing the contrast of the mask acts to sharpen the edge of the mask. Adjusting the brightness expands or contracts the mask slightly. If you feathered a selection too much, this can sharpen up the edges some.

Use **Image>Adjust>Brightness/Contrast** and crank up the contrast. Adjust the brightness value to fine-tune the edge of the mask.

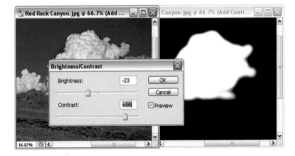

Expanding or contracting the mask This is similar to expanding or contracting the selection. Make the overall mask slightly larger or smaller, and thereby change the area of effect for an adjustment layer. Use **Filter>Other> Maximize** to expand a mask. Use **Filter>Other>Minimize** to contract the mask. You may need to try both options to see which works best. This is also good for removing the halo around the edge of a mask.

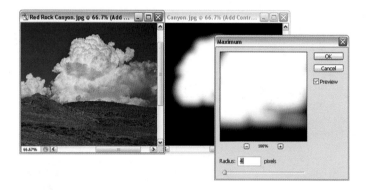

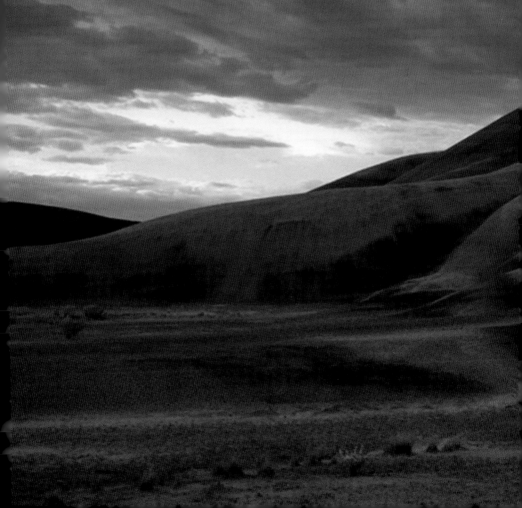

CHAPTER 4
PRINTING

Printing is a fairly straightforward process. You will have two choices for how complicated you want to make this process. You choose depending upon the print quality you want and the amount of effort you'll extend to achieve it:

■ Current desktop printers and online printing services all produce good results when used as designed. Most users are pretty happy with the basic results of a typical inkjet printer. If you're one of them, print using the steps outlined in the "Basic Printing" section in this chapter.

■ Advanced photo printers provide options for printing with profiles. Some users will want to take advantage of the full color range of their photo printers and more precisely print their image colors. The "Advanced Printing" section in this chapter outlines the steps for printing using profiles.

The real challenge in printing is to accurately match your printer colors with the monitor colors. In the illustration below, compare the monitor image with the print of the same image. See the subtle changes in colors and saturation? The print image doesn't accurately match the color quality of the monitor image. But it can by following the three key steps of "Color Management":

1 Profiling your monitor color.

2 Setting up an image "Color Space".

3 Configuring your printer driver for each print.

Everyone needs to follow these steps for color management to get your monitor and printer images to match.

Loss of saturation (blues) Color shifts (greener yellows)
Monitor image **Printer image**

What is Color Management?

To understand color management is to realize that your digital darkroom actually contains at least three different image versions: the virtual image inside the computer, the monitor image on the computer screen, and the print image on the paper.

The virtual image is how the computer (or Photoshop) sees your image. This is the precise digital version of your image, and for color management, we'll assume the most exact image version. Monitor and printer images are not exact; innate faults within monitors and printers render the image incorrectly. We can fix this, though, by preparing monitor and printer Profiles. A Profile is a list of target colors assigned value corrections so colors map precisely from the virtual image to the monitor or printer image.

Monitor image

Printer image

01110011
11001100

Virtual image

Your digital darkroom contains at least three different images: the virtual image, the monitor image, and the printer image. The goal of color management is to render the monitor image and the printer image the same as the virtual image by using profiles.

Let's take a closer look at the monitor image. The monitor image is the computer's attempt to display the virtual image on the computer screen, but, unless given some help, it fails to do it exactly. For example, assume that the virtual image contains a specific shade of red, let's say "Red#87." Photoshop knows the exact value of Red#87, but the monitor fails to display that exact value. It may add 3 points of blue. A common mistake many users make is to try to eliminate this blue in the virtual image, only to change Red#87 to a completely different color. The correct way to solve this problem is by preparing a monitor profile. Red#87 can be defined within the profile as 3 points more yellow to

correct the blue so it displays accurately on the screen. Acknowledging the error value of a specific color on a particular device allows correction for that error inside the computer before rendering the color.

A profile is a list of target colors with value corrections to allow precise color rendition by a particular device. By using a profile, we can present a particular target color and correct it so it is accurately rendered. Monitors and printers must be profiled and color corrected independently.

You need to create a profile specifically for your monitor. See the Appendix on Monitor Profiling.

Printer profiles are more complex. A good printer profile addresses a specific printer, ink set, paper type, and software settings. There is a variety of sources of good printer profiles, though. Your printer driver likely includes a good set of profiles to work with the inks and papers designed for it.

Monitors and printers are profiled and color corrected independently. If we set up both the monitor and the printer to match the virtual image inside the computer, then the printer and monitor should match each other as well.

Devices have another limitation. The real world has a vast array of colors: saturated, brilliant, subtle, muted, dull, and gray. No device can reproduce all of these colors.

The Gamut of a device is the range of colors it can render. Colors outside this gamut simply cannot be rendered by that device. Were you to try, the device would render a similar color it could display.

Due to the differences between monitor and printer gamuts, you cannot assure the monitor image matches the printer image. Colors that appear on the monitor may simply be unprintable.

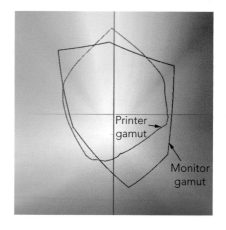

Printer gamut

Monitor gamut

To resolve the mismatch in printer and monitor gamuts, restrict your virtual image colors to those within the printer gamut. If your virtual image only contains printable colors, the monitor and the printer prints can both render them accurately. Restrict the colors by selecting an appropriate color space for your virtual image.

 Restrict virtual image colors to printable colors by selecting an appropriate color space. These colors can be both displayed by your monitor and printed on your printer.

Color Spaces

A Color Space defines the virtual image boundary of colors used to display and print. The boundary of a color space is the upper limit of Red, Green, and Blue (RGB) number values that render into real colors.

The most common color spaces used for image editing are: sRGB, AdobeRGB, ProPhotoRGB, and ColorMatchRGB. Each holds a particular range of RGB values. **Select an appropriate color space for your print image work.**

sRGB sRGB is the standard default color space for the Internet. Images created supporting sRGB should look the same on any monitor across the Internet. Although a ubiquitous color model for the Internet has not yet been achieved, progress has been made, and the computer industry has adopted sRGB well, making it the standard for many programs and devices including printers. Its main limitation is it holds the smallest Gamut of all three color spaces.

Use sRGB to create web images – it's the Internet standard. Use sRGB if you wish to forget forever about color spaces. It is the easiest color space to use.

AdobeRGB AdobeRGB is the most popular color space for digital photographers. AdobeRGB has a slightly larger Gamut than sRGB. It includes most of the colors of a typical photo printer (but not quite all!).

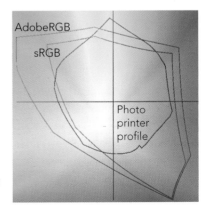

Use AdobeRGB to ensure access to the most colors your printer can print. (This is especially important if you want to take full advantage of the latest inkjet photo printers.) You'll likely print with profiles (see "Advanced Printing"), if you use AdobeRGB. And you will still use sRGB for web images and those printers that don't support AdobeRGB.

ProPhotoRGB ProPhotoRGB has recently become a much more popular color space for professional photographers. Larger than AdobeRGB's Gamut, it includes all colors likely available in printers for many years to come. But with such a large color space, it's very easy to edit colors that are eventually unprintable. And finally, ProPhotoRGB includes colors that cannot even be rendered on any monitor.

I don't recommend ProPhotoRGB for beginners, even though it allows access to all colors any printer can print. ProPhotoRGB is available for professional printers.

ColorMatchRGB ColorMatchRGB is a color space used by commercial print shops for editing RGB images. Your print shop may ask you to provide images in ColorMatchRGB. To accommodate, either use ColorMatchRGB as your working space or convert your images into ColorMatchRGB.

Color Space Settings

Use the Color Settings dialog to configure color space by selecting Edit>Color Settings.

Change the settings Option to the Web/Internet option appropriate for your region of the world (North America, Europe, Japan, etc.). These are the easiest defaults for basic color management, plus, you definitely should use these settings if you are creating images primarily for the web.

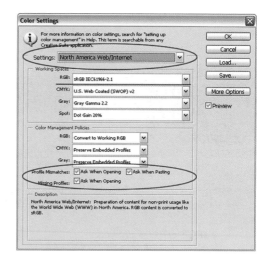

To change your default RGB color space, change the RGB: option under Working Spaces. Usually you want "AdobeRGB" if you change the default from sRGB. Leave CMYK, Gray, and Spot as defaulted.

Under Color Management Policies, leave the default RGB: policy as "Convert to Working RGB." As a result, an image opened in color space other than your default color space causes an "Embedded Profile Mismatch" dialog to open warning that the image color space is not the same as the working color space. It gives you the option to use, convert, or discard the embedded profile. Typically, you would convert images into your default color space.

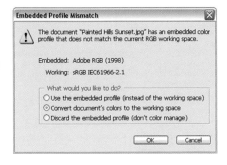

Convert to sRGB

If your default color space is AdobeRGB, you must convert your images to sRGB for uses where sRGB is assumed; for example, preparing images for web pages, placing images in standard office applications, or sending images to most printers. Otherwise color results can be unpredictable typically drab, as illustrated.

sRGB original printed as an sRGB image **AdobeRGB original printed as an sRGB image**

To convert an image to sRGB, select Edit>Convert to Profile. Just set the Destination space to "sRGB..." and set the Intent to "Perceptual" as shown. Click OK to convert. Likely, you image will appear unchanged.

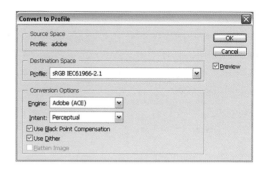

Components of a Good Print

Paper **Paper is one of the most important components of a good-looking print** and often the most overlooked. Even inexpensive printers can produce excellent prints with the right premium paper. My Epson 980 printer is several years old, yet still produces great prints when I use Epson Heavyweight Matte photo papers. The printer and the paper are manufactured to work specifically and especially well with each other. Check your printer manual for papers designed specifically for your printer. **Pick the best paper to get the best print. For Basic Printing, use the printer manufacturer's premium photo papers**. Advanced Printing using printer profiles allows for a vast array of papers from various manufacturers. However, you should still stick to using your printer manufacturer's inks.

Printer driver settings The printer driver includes settings for specifically supported papers, print quality, and color correction. It is important all are set properly. Check your printer manual for specific instructions. The number one cause of bad prints is incorrect printer driver settings. (More on this in the section on Basic Printing in this chapter.)

Color space Good color can only happen if your images are in the correct color space when printed. You should print your images in sRGB unless your printer specifically supports other color spaces like AdobeRGB, or unless you print using profiles as outlined in the section on "Advanced Printing" in this chapter. See the "Convert to sRGB" section in this chapter.

Viewing lights Printers are generally designed to create images that look accurate when viewed under daylight. But most people view their prints inside under tungsten lights which are much more yellow and dimmer than sunlight. Viewing under tungsten lights results in images that appear to have little shadow detail and a noticeable yellow cast. It's best to get a good viewing light. Professionals use expensive D50 viewing lamps available from quality lighting stores. Many office supply stores carry more moderately priced desktop daylight fluorescent lights. Other photographers use desktop halogen lights – the 20–35 W models produce a good bright light. Even though halogen light is still noticeably more yellow that daylight, it is often considered a better match for viewing prints indoors. **Get a good bright light for viewing your prints**.

Printer Many people believe only expensive, dedicated photo printers print excellent images. **But most desktop printers print very good photographs**. The biggest advantage of dedicated photo printers is prints that will last many years; manufacturers claim over 100 years. This isn't trivial if you want your photos to last. The best photographers look to the newer photo printers designed to print extremely rich colors and gorgeous black and whites.

But don't run out and buy a new, expensive photo printer right away. Learn the process for good image editing and printing on your current printer. If you're in the market to buy one, at least buy an inexpensive, modern desktop printer. As you learn, you'll better determine your own needs and make a better choice when you buy a professional level printer.

Proof Prints

I often make a quick proof print to see where the image really stands. Make it 5″ × 7″ (18 cm × 12.5 cm) to print quickly on a desktop printer, yet be large enough to evaluate. Print it onto an A4 or letter-sized sheet of paper; the unused white space provides a good frame for the proof print.

Printing a Quick Proof Version of Your Image

To quickly print a 5″ × 7″ (18 cm × 12.5 cm) version of your image, you change the print size in the Print with Preview dialog in Photoshop. For final prints, resize

your image in this dialog, since it's not as precise as using the Image Size dialog. But it is adequate for a quick proof print:

1 Do not resize your print for the proof.

2 Select File>Print with Preview. In the Print with Preview dialog, change the *Height* **or** *Width* option under *Scaled Print Size* to create a 5" × 7" or 18 cm × 12.5 cm print; changing one will automatically change the other. I typically make the larger of the Height or Width 7" (18 cm).

3 The preview will display the layout of your image on the page. You may need to select the Page Setup option to go to the Page Setup dialog to select letter size paper or rotate paper orientation. The Preview should display the 5" × 7" version of your image nested inside an A4 or letter-sized layout.

4 Finish by printing normally. Use the steps in the "Basic Printing" section in this chapter.

5 The next time you open the Print with Preview dialog, ensure that *Scaled Print Size* is set to 100%.

Printing a Selection from Your Print

If your image is larger than A4 or letter sized, you may wish to make a proof print of a 5" × 7" (18 cm × 12.5 cm) selection out of your image. This allows you preview a piece of the image as it will print in the final image:

1 Make sure your image has no current selections; **Select>Deselect**. Select the *Rectangular Marquee* tool from the tool bar. Look that the options bar for the *Rectangular Marquee* – it has an option to create

selections for a fixed size. Change the *Style* on the options bar to *Fixed Size*. The Width and Height options now become available. Make these 5 and 7 in (or 18 and 12.5 cm, respectively).

2 Place the selection on the image – just click on the image and a rectangular selection will appear with the correct dimensions; you can move this selection around by dragging it to get the exact placement that you want. If the rectangular selection is the wrong orientation (i.e. vertical when

you want horizontal), click on the Switch arrows between the Width and Height options on the options bar.

3 Select **File>Print with Preview**. In the Print with Preview dialog select the Print Selected Area option under Scaled Print Size. Photoshop will now print only your

selection (which is exactly 5″ × 7″ or 18 cm × 12.5 cm). Note that the preview does not display the selection as it will appear on the final print – this is a "Feature" of Photoshop.

4 Print the image normally.

Preparing Images for Print

Now you are ready to make a final print. This chapter covers a quick and easy process that I perform to prep any image for print.

Up to this point, the work that you have done to your image isn't particularly dependent on the final target for the image; the final size or print medium. But now you will perform edits on your image that are specific to the final size and print medium. I often don't know how my images will be printed when I start working on them, or I want to be able to print an image in a few different ways; so I make sure that these printer-specific steps are performed after I have completed all of my basic edits and saved the edited image.

This may seem like a lot of work to just get your image ready to print, but with some practice, you will be able to perform all of these steps in about a minute.

You may just want to make a "quick" print to see how the image will look when printed without going through the bother of properly resizing the image or sharpening the image. I call these quick proof prints – look for how to make these in this chapter.

Outline of the Print Prep Stage

- **Saving the edited image** – You have been working on your image for a couple hours now, and before you rush into printing the image, save it. The printing process involves several steps that alter your image in ways that are specific to a particular size or paper type. Save the file as a Photoshop file to keep all of the edit and layers.

- **Flatten the image** – Once you have saved the file, it is no longer necessary to have all those layers; and it is generally best to sharpen on a flattened image file.

- **Determine the print parameters** – You need to determine the printer, paper, and print size that you want for this image.

- **Crop the image** (if appropriate) – Often the final print needs to match a particular aspect ratio (i.e. 8 × 10 or 5 × 7). If you need to match a specific height and width, then you will likely need to crop the image to fit.

- **Resize the image** – Resize the image to the target print size (i.e. 8″ × 10″) and the appropriate printer resolution.

- **Sharpen the image** – Digital images generally improve with a modest amount of sharpening. I always sharpen right before I print.

- **Print –** Make sure you have the printer driver set to the optimal settings for your particular paper; print.

- **Save the print file** – If you like the results, save the print file; this file is specific to a particular print size and paper; if not, go back to the file you saved in the first step and continue editing.

Save the Edited Image

Likely your will already have a saved file for your edited image; it will be named something like "*My Image* Edit". Go ahead and save this image so that you have a protected version of the image that includes all your edits and layers. Select **File>Save**. If you haven't saved the edited image, go ahead and save a new file for your edited image (your image will have the name of the original file that you opened for that image, or perhaps the clean file name "*My Image* Clean"). Select **File>Save As...**; in the Save As dialog, change the name to "*My Image* Edit" and save it.

Duplicate the edited image Maybe this is a bit too hardcore, but I recommend making a duplicate of your edited image on which you can perform all of your print prep steps. Select **Image>Duplicate...**; in the Image Duplicate dialog, change the name to "*My Image* Print." (I often use an even more specific name that includes the printer and size, like "*My Image* E2200 8 × 10 Print.") Select "Duplicate Merged Layers Only" to flatten the image and skip the next step.

Flatten the Image

Once you have saved the file, it is no longer necessary to have all those layers; and it is generally best to sharpen on a flattened image file.

Select **Layer>Flatten Image**. This option isn't available if you already have a flattened image.

Determine the Print Parameters

For a high-quality prints, you will need to resize the image for a specific printer and size. You get to pick these (you are the artist here). Just select the printer and the size that your want to print. Remember that your image needs to be able to fit onto the paper – an 8″ × 12″ image won't fit onto an 8½″ × 11″ piece of paper.

If you want the image to fill a specific sized piece of paper; or you will be placing the image into a document for printing; you may need to print to a specific shape and size; you will need to crop your image.

Crop Your Image

Often your image doesn't have the right shape to fit your final print. Typically, images from digital cameras mimic the long format of 35 mm film, a format that has the proportions of 4 × 6. If you want to fit this into a more traditional print proportion, like 5 × 7 or 8 × 10, you will need to crop off some of the long end:

1 Select the crop tool from the toolbox.

2 On the Options Bar for the crop tool, input the Width and Height for the target print; this will ensure that you crop to these specific proportions. Make sure the Resolution is blank; you will set the resolution when you resize the image.

3 Drag the crop tool across your image to roughly define the area of the crop; the crop tool restricts the crop to the proportions entered in the Option Bar; you can make the crop any size your want. If the crop tool restricts you to a vertical crop, and you want to make a horizontal one (or visa-a-versa); hit **esc** to cancel the crop tool, and hit the switching arrows between the width and height to change these, and drag the crop tool across your image again.

Once your have drawn the crop to fit your final image. Hit the **return** key to accept the crop.

Resize the Image

You should not have resized your image at any point yet. Computers are very good at resizing and scaling images, but there are some potential problems with resizing, so generally **you should only resize your image once** – when you are getting ready to print.

The resolution of your image doesn't really matter to Photoshop; Photoshop views the image merely as a large array of pixels without any specific "size." As you edit, your image may have a wide range of possible resolutions – many digital camera images have a resolution of 72 pixels per inch (ppi), and sizes around 20" × 24"; scanned 35 mm film usually has a resolution around 4000 ppi, and a size of ~1" × 1½". You'll set the appropriate size and resolution right before you print.

To resize, select **Image>Image Size** to open the Image Size dialog.

New (and old) pixel dimension

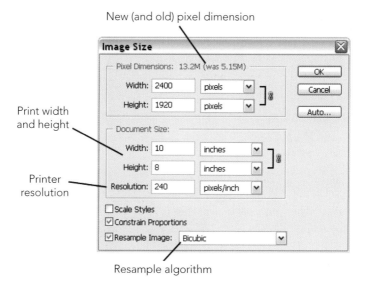

Print width and height

Printer resolution

Resample algorithm

Make sure that the option for **Constrain Proportions** is set to ensure that we don't stretch or squish our image. Also, make sure the option for **Resample Image** is set.

Input the target Width or Height, since these will change in proportion, changing one, will also change the other.

Input the target resolution for your printer. **Almost all print devices print at a resolution of 300 ppi**; if you don't know your printer's resolution, set this to 300 ppi. For Epson printers, use a resolution of 240 ppi; for images with very sharp details, printed onto glossy papers or film, Epson printers can also use a resolution of 360 ppi.

 Some printers used by online services to print onto traditional photographic papers (like Lightjet, Chromira, or Frontier printers) have unusual resolutions like 304.6 ppi. But these printers generally do a very good job of resizing your image to this exact resolution. For these printers, set the resolution to 300 ppi.

Finally, you need to set the appropriate **Resample Algorithm**. Up at the top of the dialog are the New (and Old) Pixel Dimensions for this image; if the new dimension is bigger than the old one (you are adding pixels to your image), then set the Resample Algorithm to **Bicubic Smoother**; if the new dimension is smaller than the older one, set the Resample Algorithm to **Bicubic Sharper**.

 There are lots of add-on tools for Photoshop that perform sophisticated resampling algorithms; these tools often provide some benefit for resizing images to large sizes while maintaining sharp detail. This was a major issue for earlier version of Photoshop, but the options available in Photoshop CS2 are quite good for most images.

Sharpening

Photoshop CS2 introduces an excellent new tool for sharpening images – the

Smart Sharpen filter. This tool is both easier to use than the traditional sharpening tools, and it sharpens better. Always sharpen after you have resized your image – sharpening before resizing can create ugly artifacts:

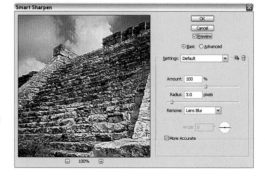

1 Your image should be flattened to have only

one layer; the Smart Sharpener only works on a single-image layer. Plus, make sure that your image view is set to "Fit on Screen," so you can preview the entire image.

Select **Filter>Sharpen>Smart Sharpen**.

2 Within the Smart Sharpen dialog, set the Amount to 100%, set the Radius to 1/100th of your print resolution (the radius is typically 3 pixels for prints), and set the Remove option to "Lens Blur."

Turn on More Accurate – this slows down the filter considerably, but the time allow this filter to run is well worth it.

That's it; for many images these settings work fine.

Well sharpened Over sharpened

You may wish to experiment with the Amount to obtain the best sharpening, but be cautious, too much can create harsh black and white lines around an sharp details in your image.

If you over sharpen an image, you can turn down the sharpening quickly by using the Fade command; **Edit>Fade....** Just pull back the "Opacity" in the Fade dialog to turn down the last adjustment. This is a good, simple tool when you have applied an adjustment too strongly.

Localized Sharpening

Localized sharpening is one of the easiest and most effective of the power sharpening techniques. Leaving some of the image unsharpened will make the sharpened areas of the image stronger and more noticeable.

1 Duplicate the background layer for your image (your image should be flattened earlier in the print prep); select **Layer>Duplicate Layer**, and name the new layer "Sharpen Layer." Select **Filter>Sharpen>Smart Sharpen** to sharpen the new layer.

2 Run the Smart Sharpen filter as suggested in the previous section on "Sharpening."

3 Add a layer mask to the "Sharpen Layer;" click on the add layer mask icon at the bottom of the Layers palette. The new mask will be white everywhere, revealing the sharpen layer everywhere.

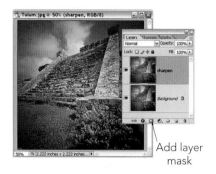

Add layer mask

4 Select the paintbrush tool, select the default colors and switch these so that the foreground color is black, and paint over the image where you want to hide the sharpening. This allows the sharpening to focus on the important parts of your image.

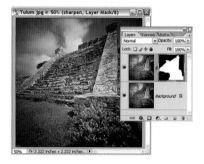

Edge sharpening If your image has lots of grain or other texture, you may need to perform edge sharpening in order to sharpen well without also sharpening the grain. Grain is common in images shot on some color or b&w negative films, especially high-speed films. The instructions for edge sharpening are available on the web site.

Print

Finally the print stage. You will likely be printing your images onto a desktop printer, via an only image printing service, or through a print service bureau. You can chose to print using the basic printer driver settings as outlined in the next section on "Basic Printing." Or you can print using profiles as outlined in the section on "Advanced Printing" in this chapter.

After you print your image, make sure that you evaluate it under good light, ideally some sort of daylight balanced light or a good, bright halogen light. The colors and density will be much easier to see under a good light.

Add an Annotation

 Annotations are a great way to add details about the printing process to an image and keep all these details together with the print file. Select the Note tool from the toolbox and click on the image; this will add an annotation "sticky."

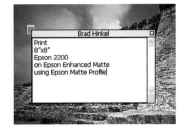

Fill in all the details about how to create a good print from this file, include printer, paper, printer settings, profiles, and other printing details. Annotations can only be saved as part of a Photoshop PSD, PDF, or TIF file.

Save the Print File

Once you have a print file that you like, save it under a name that will help you to identify the image and printing process later; include the print size and print technique in the file name; "*My Image* Print E2200 8 × 8" for an Epson 2200 print at 8" × 8". If you have added layers in the print prep process, go ahead and flatten the image again. Save the Print file as a TIF file.

 Most desktop printers and many online print services will add some additional contrast to your image in the printer driver. This is designed to make the prints just a bit snappier – it ticks me off, I want the driver to print my image exactly as I send it to my printer. This can be corrected before sharpening. Details on how to measure the contrast added by your printer and how to fix this is on the web site.

Basic Printing

Today, most printers produce excellent color prints as long as you work with the manufacturer's papers and inks, *and* you properly configure the printer driver:

1 Now that you've done all the print prep, we're ready to print. Convert the image to sRGB (page 107) if needed.

2 Select **File>Print with Preview...** to access the Print with Preview dialog. The first time you access this dialog, the default settings are set properly for basic printing. But look at the color management settings to understand what they do.

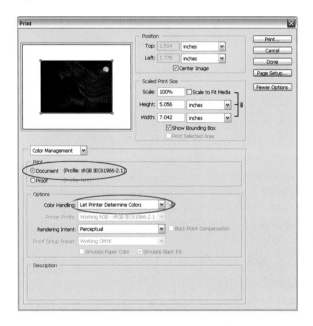

In the Print area, the option for Document should be selected. This also displays the profile or color space for the image to be printed.

In the Options area, the Color Handling option is set to "Let Printer Determine Colors." This allows the printer driver to handle the color for this image; Photoshop merely passes the image to the printer driver unchanged.

The "Rendering Intent" option is set to "Perceptual." Perceptual is the default rendering intent for most printer drivers.

The Rendering Intent defines how the image colors are converted from one profile into another. Use the Perceptual intent for basic printing and the Relative Colorimetric intent for advanced printing.

In the Position area, the Center Image option is checked. In the Scaled Print Size area, the Scale option is set to 100%.

The preview window reflects at this point how your image would print onto the paper you've selected.

3 Click on the Page Setup button to open the Page Setup dialog. This dialog is different on the Mac and on Windows.

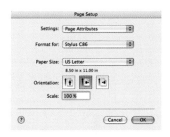

On the Mac, you select the Printer, Paper Size, and Orientation for your print. First select the printer you want, then select appropriate paper size and orientation.

On Windows, you must select the Printer button to access the Printer Select dialog to select a printer other than the default printer. In the Page Setup dialog, select appropriate paper size and orientation. Press OK in the Page Setup dialog to return to the Print with Preview dialog.

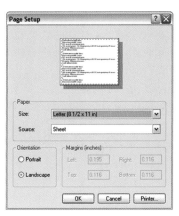

4 Now the print preview reflects your image centered on the paper size you selected. If your image appears much larger or smaller than the paper size, you probably didn't follow the print

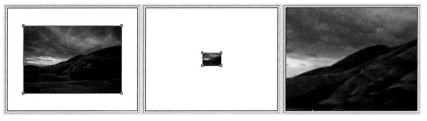

Print preview for a typical image on letter size paper; and images that were not properly resized

prep steps properly to resize your image. Cancel out of the Print with Preview dialog and resize the image.

5 Once the preview looks good, and the Color Management settings are correct, click the Print button. Once again the dialog is different between Mac and Windows.

Mac Print Dialog

In the Mac Print dialog, select the Print Settings option to access the settings for your printer driver. These settings differ for each type of printer, but almost all printer drivers have options for Paper (or Media) Type, Mode, and Quality. Set Paper Type to match the paper you're using (You'll only have choices of the manufacturer's papers; here Epson's "Matte Paper – Heavyweight.") Set Mode to Automatic and Quality to the highest setting available. Check your printer's manual for details on these printer settings.

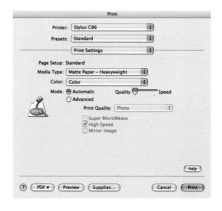

Next, change Print Settings to the Color Management option. (Some printer drivers refer to this setting as ColorSync, while some have no color management options at all.) For most printers, the default Color Management option is set to Color Controls or Automatic; this works best for most

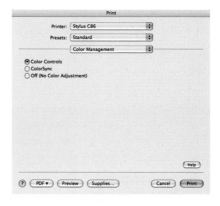

printers. Your printer may also have an option for ColorSync; this may allow your printer-to-printer images in color spaces other than sRGB. Check the printer manual for details on ColorSync.

Finally, click on Print to print the image.

Windows Print Dialog

In the Windows Print dialog, select the appropriate printer from the printer list, and click on Properties . . . to access that printer's print properties dialog.

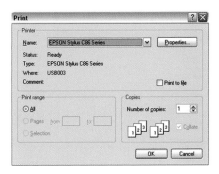

The Properties dialog is different for each type or printer, but almost all printer drivers have options for media type, print mode, and/or print quality. Set the Paper Type option dropdown to match the paper type you want. (You'll only have choices of the manufacturer's papers; here Epson's "Matte Paper – Heavyweight.") Set the Quality option to the highest-quality setting available. If available set the print mode to Automatic, Photo, or Quality.

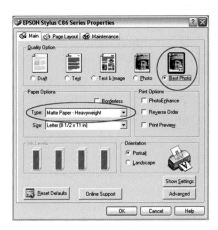

Look for the Color Management options for your printer; these may be available on the Advanced page for the printer driver. The default Color Management option is set Color Controls or Automatic for many printers. This works best for most printers. Your printer may also have an option for ICM; this may allow your printer-to-printer images in color spaces other than sRGB. Check the printer manual for details on ICM.

Finally, click on Print to print the image.

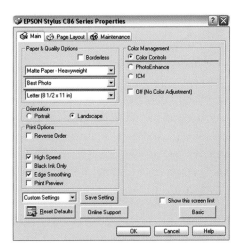

 In the Printer driver dialog, select the paper or media to exactly match the paper you are using, set the driver to print the highest quality, and set the printer's Color Management to Color Controls or Automatic. You might also use ColorSync or ICM for color management.

Online Printing Services

Online printing services allow you to upload your images via the Internet and have high-quality prints made onto traditional photographic media. Online printing services have some great advantages: they produce images with the look and feel of traditional photos, they're generally cheaper than similar inkjet prints, they don't require a complex printer dialog, and they typically offer sizes from 4" × 6" (15 cm × 10 cm) up to poster size (20" × 30"). The only major disadvantage of online printing services is the printing is somewhere other than your desktop so takes to get the final prints.

Photoshop CS2 supports online printing directly via Adobe Photoshop Services handled in North America and Europe by Kodak EasyShare Gallery. Similar services are available in other parts of the world.

Kodak EasyShare is an excellent example of a consumer online service. Prints from Kodak EasyShare can be excellent if you conform to their requirements.

To print with Kodak EasyShare, an image must be saved as a Jpeg file in the sRGB color space. If your image is already a Jpeg file in sRGB, you can skip to Step 5:

1 To duplicate your image select **Image>Duplicate Image...** Give the duplicate image a simple name – "my image web print," for example. If your image has layers, select the option Duplicate Merged Layers Only.

2 Make sure your image is in the sRGB color space (to convert to sRGB, see page 107).

3 Make sure your image is set to 8 Bits per channel to make a Jpeg file. Select **Image>Mode>8 Bits/Channel**.

4 Save your image as a Jpeg file, select **File>Save As…**, set Format to Jpeg and click OK. In the Jpeg properties dialog, set quality to 9 – "High."

5 Send a single file to print online by selecting **File>Print Online** in Photoshop. But more often, you want to save a set of images and print them all together. Once you have a set of images ready, open Adobe Bridge by selecting **File>Browse…**

In Adobe Bridge, select the images you want to print online, and then select **Tools>Photoshop Services>Photo Prints…** This opens the Kodak EasyShare Gallery and loads your images. (The first time you access Photoshop Services you need to register with them, i.e., supply some basic information and create

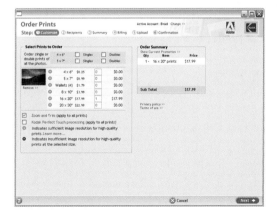

a login id and password.) Within Kodak EasyShare, merely select the prints for each image and check out. If you made sure your images were in the correct format, excellent images will arrive in a few days.

Advanced Printing

The main focus of advanced printing is printing with printer profiles designed specifically for your printer and paper. The main advantage of printing with profiles is a more precise match between monitor and printer right before printing. This allows careful editing of print colors on the computer before you print and the ability to use most or all of the color range available from your printer. In order to print with profiles, you will need to obtain the appropriate profiles for your printer.

Manufacturer's profiles The easiest source of profiles is from the appropriate paper manufacturer (including the printer manufacturer for the papers that they sell for that printer). Printer profiles are widely available for a modest number of photo printers on the web sites of a number of paper manufacturers. Many make excellent profiles for their papers and a number of printers popular with professional print makers. Epson, Ilford, Kodak, Legion Paper, Red River Paper, Pictorico, and others provide printer profiles for their papers via the Internet. And often the paper box provides a web site for profiles. **You need to obtain profiles for your specific printer model and paper type**. Usually, profiles are only available for the printer manufacturer's inks, but if the printer can use multiple types of ink (like the Epson 2200 or R2400 printers), be careful about which inks you use. Additionally, **find specific instructions for each profile on configuring the printer driver**. If the driver settings are not configured on your computer the same as the instructions for the printer profile, the profile won't print properly.

**Custom profiles You can also have custom profiles made for you by a professional profile service. These have some good advantages but cost money. A quick Google for "custom printer profiles" found several services for around US$40/€30. These companies provide a test target and instructions on how to best print this target. Once you print the target, snail mail the physical target to the profile service and they e-mail you the specific profile. Purchase a profile for each paper type you'll be using.

**Installing profiles Once you download the profiles, you need to install them. Some of the manufacturer's profiles include an installer that install the profile for you, but most require you install them yourself.

On Mac OSX, copy the profiles to the appropriate directory. If you have admin privileges for your computer (most users running their own desktop computers have admin privileges), use the <drive>/Library/ColorSync/Profiles folder. Just move the profile files to this location. If you don't have admin privileges, use the <drive>/Users/<username>/Library/ColorSync/Profiles folder.

Mac icc icon

You'll have private access to profiles in this folder. Once installed, you'll be able to use these profiles from within Photoshop.

On Windows XP, install the profile by right-clicking on the profile and selecting **Install Profile** from the context menu. This action copies the profile to the appropriate directory.

Profile names Profiles can be named almost anything, but there's a general consensus that a good profile name includes a reference to the printer model, paper, and ink (if appropriate). A typical Epson profile is named "EP2200 EnhancedMatte 2880MK.icc" – the printer is EP2200 (Epson 2200), the paper Enhanced Matte, the ink Matte Black (MK), and the printer resolution 2880 dots per inch (dpi). With some practice, understanding profile name will become a snap.

Set Up the Proof

One advantage of printing with profiles is the ability to Soft Proof the image before printing. Soft proofing allows Photoshop to mimic the look of the final print on the monitor:

1 To set up soft proof, select **View>Proof Setup>Custom...**

2 For Device to Simulate select the printer profile for the printer/paper combination you'll use to print.

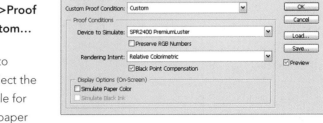

3 Set Rendering Intent to "Relative Colorimetric." (More on rendering intents on the web site.)

4 Turn on Black Point Compensation. This matches the black point in your image to the black of the ink used by the printer.

5 Use the Simulate Paper Color option to better mimic the look of the print in the proof. Often selecting this option makes the image appear washed out. So don't select this option for bright white photo papers, but definitely use it for papers that are noticeably off-white.

6 Save a proof setup you use often by clicking the Save button. Give it a useful name incorporating the printer and paper names, like "EPR2400 Prem Luster." This name then appears at the bottom of the View>Proof Setup menu for easy access in the future.

7 Photoshop now displays a soft proof of how your image will print using this profile. There might be some minor color shifts in the print to correct at this point. Display a new view without the soft proof by selecting **Window>Arrange>New Window...** for before and after views. The title for each view displays if a profile was applied to it.

Resolving Out of Gamut Colors

Quality profiles yield very little color shift with the "Relative Colorimetric" rendering intent. But no profile can perfectly resolve the printing of "unprintable" colors; that is, out of gamut colors.

Out of gamut colors simply cannot be rendered by your print on the target paper – deal with it. If you take the trouble to print with profiles, you should work to resolve out of gamut colors manually:

1 Display the out of gamut colors by selecting **View>Gamut Warning...** As illustrated, pixels that contain colors out of gamut display with a gray

overlay. If no pixels display gray, or if there are only a few "speckles" of gray on the image, don't worry about the gamut and print the image.

If there are large areas of solid gray in the image, shift these colors to printable colors. Printing an image with large areas of out of gamut colors results in an image with large patches of solid color.

2 Use the Replace Color tool to shift out of gamut colors. Select **Image>Adjustments>Replace Color...**

3 Move the cursor over the image and click on one of the large patches of gray. This makes the out of gamut color the Color at the top of the Replace Color dialog.

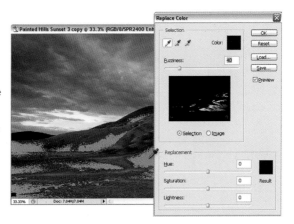

4 Next, select a color in gamut to replace this color. Click on the color square for the Result color. This brings up the Color Picker. Move the cursor over the image and click on a color that is similar to the out of gamut color, but in gamut. When you click on a replacement color, the gray of the gamut warning dramatically reduces. Try a few colors to see which color provides the best result. Click OK to close the dialog.

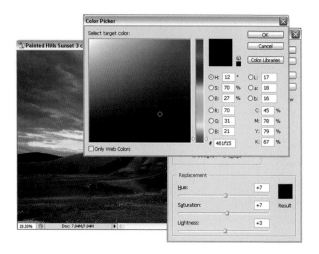

5 It's important to preview the change. Select **Undo/Redo** (⌘ / ctrl +Z) a couple of times to turn the replace color change on and off.

6 Finally, reduce the effect of the Replace Color tool to as low a value as possible. Select **Edit> Fade Replace Color...** Reduce the opacity of the Fade until the gamut warning begins to appear again. It's best to print with some gamut warning, so you're printing right at the edge of the gamut and taking advantage of the full range of printable colors.

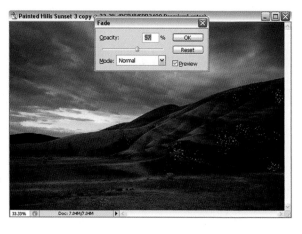

It is possible that you will need to perform the Replace Color adjustment more than once for different colors. Repeat these steps until the gray of the gamut warning is reduced to a mere speckle.

Printing with Profiles

Once you've adjusted the image to fix the out of gamut colors in the Soft Proof, printing is similar to the basic printing steps:

1 Select **File>Print with Preview...** In the Print with Preview Dialog, select Page Setup to access the page setup dialog, then select the appropriate paper size and orientation.

In the Print area, select the Proof option. This also displays the profile you set up earlier.

In the Options area, set Color Handling to No Color Management. Color management has already been handled by the Proof setup. Finally, set Proof Setup Preset to Current Custom Setup and turn off Simulate Paper Color and Simulate Black Ink.

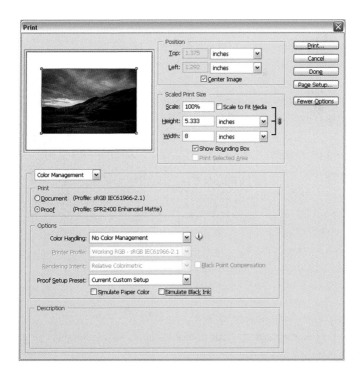

2 Click Print to access the Print dialogs. Once again the dialog is different between Mac and Windows.

Mac Print Dialog

3 In the Mac Print dialog, select the Print Settings option to set the settings within the printer driver. Here you need to know the appropriate printer settings for the profile you're using. **The profile is useless without knowing the appropriate printer settings**. Use the instructions that came with the profile to set up

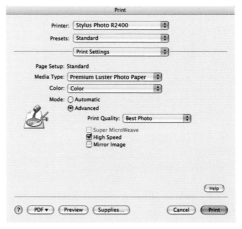

the Print Settings options appropriately. This includes appropriate settings for media, print quality, resolution, and color management. For most printer profiles, set the color management options to "no color management" – unless specified otherwise.

Finally, click on Print to print the image.

Windows Print Dialog

In the Windows Print Dialog, select the appropriate printer from the printer list and click on Properties . . . to access the print properties dialog for the selected printer:

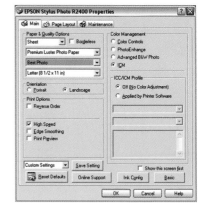

4 Here you need to know the appropriate printer settings for the profile you're using. **The profile is useless without the appropriate**

printer settings. Use the instructions that came with the profile to set up the Print Settings options appropriately. This includes appropriate settings for media, print quality, resolution, and color management. For most printer profiles, set the color management options are sent to "no color management" – but not always.

Finally, click on Print to print the image.

CHAPTER 5
ADVANCED OPTIONS

This chapter provides a location for all the advanced techniques that should be included in a book on image editing in Photoshop because they are commonly used. But these techniques require some advanced knowledge that is best left until after you have a solid understanding of the basics of Photoshop.

A key for many of the tasks included in this chapter is the process of blending layers. The next section provides a description on how layers are blended. Examples of blending layers are included in several tasks in this chapter.

The Toning section provides important techniques for adjusting image tone using tools other than the basic level and curves tool. These include more precise techniques for using levels and curves, contrast masking, dodging and burning, and shadows and highlights. These techniques can replace similar basic adjustments provided in Chapter 3, The Image Editing Workflow.

The Color section primarily provides additional options for adjusting the color balance of an image. A simple technique for using the Auto Color tool, and techniques for precisely correcting known colors like grays or skin tones are provided.

The section on Black and White (B&W) images provides techniques for converting images from color into B&W, and a simple technique for toning B&W images to simplify printing them.

Finally, the section on Photographic techniques provides a series of tasks that apply different looks to the image for aesthetic effects. These include adding film grain, adding an interesting edge, or applying Soft Focus.

Blending Layers

Finally, I include some discussion on blending layers. This is an advanced topic on creating more sophisticated blending of layers. Some of the advanced tasks in this book include steps that use these techniques for blending layers; this topic should help you understand how layer blending works.

Up to this point, a layer completely replaces the pixels of the layers that lay below it. Adjustment layers perform an adjustment on the pixels of the image, and replace these pixels with the new, adjusted pixels. Image layers merely replace pixels that are laid below them on the layers palette. You can use masks that are used to define where each layer is visible.

A layer can also be blended with the image below. There are two basic options for blending layers – opacity and blending modes. Both are important for blending layers. The default opacity for a layer is 100%. The default blending mode for a layer is Normal – the pixels of this layer merely replace the pixels below it. For many cases, these values work well, but let's consider changing them.

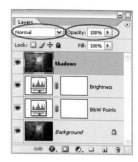

You cannot change the blending mode or opacity of the Background layer.

Opacity

The opacity of a layer is easy to understand. Lowering the opacity makes the image semi-transparent. Opacity is the opposite of transparency – a 100% opaque layer can't be seen through at all; at 50% opacity, the layer is 50% transparent, and the layer blends 50/50 with the pixels below; at 0% opacity, the layer is 100% transparent, and you can see right through the layer. Just select the top-most layer in your image and change the opacity of the layer to play around with it.

Lowering the effect of adjustment layers Photoshop is a tool that demands some subtlety for editing images. Even after many years working with it, I still often make my adjustments too strong as I work through the editing process. Opacity is a great way to "turn-down" an adjustment layer. If you decide during the editing process that a particular adjustment layer is a bit too strong, you can reduce it by merely reducing the opacity of that layer – an adjustment layer set to 50% opacity is essentially the same as applying the adjustment at 50%. Lowering the opacity also works for Merged Image layers – in fact, it is great for Merged Image layers, since it makes it easy to adjust the effect of a Merged Image layer without having to rebuild it.

Blending affects There are some affects that work best by mixing a layer with the image below by lowering the opacity. Typically, a Merged Image layer is created for the current image, a Photoshop filter is applied to the image, and the opacity is lowered to blend the filtered image with the image below the layer. The Soft Focus affect blends a blurred image with the sharp image using the Gaussian Blur filter and a lower opacity.

Blending Modes

The blending model for a layer sets how the resulting pixels in that layer blend with the pixels of layers below it to create the resulting pixel in the final image (what you see on the screen). The default "Normal" blending mode merely takes the pixels of the current layer and replaces the pixels that were below.

The various blending modes can be divided into four basic categories: Darken, Lighten, Contrast, and Color modes. The Darken modes make the image. The Lighten modes make the image lighter. And the Contrast modes make the image darker where the current layer is darker than middle gray, or make the image lighter where the current layer is lighter than middle gray. The Color modes cause the current layer to only change the Hue, Saturation, Color (Hue and Saturation), or Luminosity (density) of the image. (The Dissolve, Difference, and Exclusion modes are used mostly for special cases.)

To understand the blending modes, you need to think of a pixel for the top layer as having three basic components; the pixel combination of all the layers below the current layer, the pixel generated by the current layer, and the resulting pixel in the final image – the resulting pixel is the pixel that is actually displayed on the screen, and is passed on upwards to other layers.

The "Normal" blending mode is simple. The current layer merely replaces the pixel of the layers below the current layer.

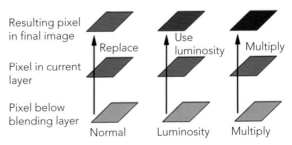

A common blending mode is "Luminosity"; this mode takes the luminosity from pixels in the current layer and combines these with the color from the pixels below to create a new pixel; one with the old color combined with the new

luminosity. The other color blending modes behave similarly, changing only the hue, saturation, or color of the pixel.

This mode is especially useful if you want a layer to only change the luminosity (or density) of the image. It is common for adjustment layers that apply significant density changes to also result in some moderate color changes. A curves

Original Contrast added Contrast added
 normal luminosity

adjustment layer that adds a moderate amount of contrast can also result in a slight change in color – changing the blending mode of this curves adjustment layer forces the layer to only change the luminosity and not change the color.

The color blending modes can be used for most common adjustment layers that adjust brightness, contrast, color, or saturation. In general, a brightness or contrast layer should only change luminosity (so the blending mode should be set to luminosity); a color or saturation layer should only change color or saturation.

Another common blending mode is the "Multiply" mode – this mode takes the pixel in the current layer and "multiplies" it with the pixel below it (don't worry about the actually process of multiplying). The multiple mode results in a darker pixel than either of the original pixels. The opposite blending mode is "Screen" – this mode takes the pixel in the current layer and "multiplies" it with the inverse of the pixel below it. The screen mode results in a lighter pixel.

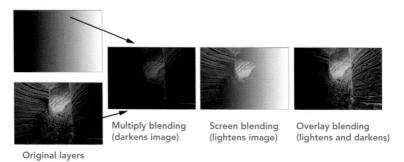

Multiply blending Screen blending Overlay blending
(darkens image) (lightens image) (lightens and darkens)

Original layers

The Overlay blending mode is a compromise between lighten and darken; where the current layer is dark, the resulting image is darker; where the current layer is light, the resulting image is lighter.

Advanced Adjustments – Tonal

The tonal value of a pixel is merely its brightness; given this simplicity, the adjustments to tonal value are generally very easy to perform. But this simplicity often hides the importance of these basic adjustments; good tonal adjustments often result in very dramatic changes to an image.

Additionally, the tone of an individual pixel is usually less important, than the relative value to other pixels, or the tonal contrast of the image. Contrast can apply to the overall image (the global contrast), and can apply just to nearby pixels (local contrast) – both are key to good image editing.

Contrast is a complex idea in photography. Contrast is the juxtaposition of differences within an image. Photographers often limit contrast to differences in tone, but it is essential to understand the broader definition of contrast to place it as a foundation of image design. Contrast can involve tone, form, texture, color, saturation, focus, sharpness, or even subject matter – all of which can help define the parts of an image. You should keep in mind the various forms of contrast (tone, color, etc.) in your images.

In this section, I will introduce various techniques that I use to edit the tone of the image – these all really involve editing the tonal contrast (global and local) of the image.

The B&W point adjustment is one of the simplest adjustments that you can make to your images, but it is often the most important adjustment. This is one of the most effective techniques for improving tonal contrast to your image.

These are all techniques that I commonly perform on my images: Dodging and Burning for quick, local edits to tone; Curves Adjustments with Locking Points to make subtle changes to a few tones; Contrast Masking to reduce overall contrast while maintaining apparent sharpness; Shadows and Highlights Adjustment to maintain detail in Shadows or Highlights.

Precise B&W Point Adjustment

In general, all images should have full contrast, from maximum black to minimum white. Usually, there should also be some detail in these B&W tones. The density of maximum black should be precisely set so the shadows still retain some density variation; I call this "nearly black". Similarly the highlights should print "nearly white". The Levels tool is excellent for adjusting the image pixels to these values precisely.

1 Create a new levels adjustment layer by selecting **Layer>New Adjustment Layer>Levels...** Name this layer "B&W Points".

2 Examine the histogram for your image; ideally the histogram will cover the full range of tones from black to white.

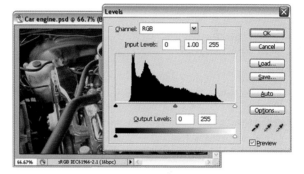

3 Slide the black input slider towards the right, the dark pixels in the image will turn slightly darker. Move the slider over just until the first pixels become pure black. To do this precisely, hold down the **alt** / **⌥** key while moving the black slider; the view of the image will go white, with a few points of black. The pixels shown as black will be turned pure black by this adjustment. You should adjust the black input slider until a few pixels are set to black.

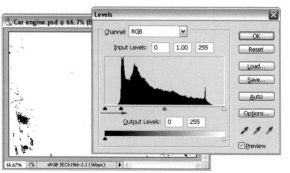

Move the black-point slider while holding the alt / ⌥ key

4 Next slide white input slider towards the left to set the white pixels; pressing the *alt* / ⌥ key while moving the white slider will show those pixels that will be shifted towards white.

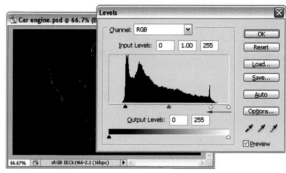

Move the white-point slider while holding the *alt* / ⌥ key

Typically, the white point should be set so that just a few pixels will display as pure white; you may even wish to pull back the white point from making any pixels pure white. Solid white parts of the image often appear artificial and may lack any smooth details that you might expect in your highlights.

Your image should now have maximum contrast from black to white.

When working on color images, holding the *alt* / ⌥ key will show the pure black or white pixels in color. These show the effect for each color channel in the image. Just work as if these pixels were not color; adjust the B&W points so that

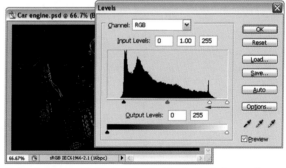

Color images will display the "white" pixels for each channel – adjust these to show just a few points of color.

just a few pixels are set to pure black or pure white.

Some Points on B&W Point Adjustments

The classic rule for setting the B&W points suggests that an image should have full contrast; from pure black to pure white with some shadow and highlight

detail. But the truth is more complicated, there are really more options for controlling the full contrast of an image.

- When printing images with strong, specular highlights (such as this image of an engine), you may wish to push the white point until these strong highlights appear as a solid point of white in the image.

| Nearly white highlights | Specular (pure white) highlights |

- For images with smooth highlights (such as portraits), you may wish to maintain a separation between the highlights and pure white. Pushing the whites of a portrait to pure white may appear ghastly.

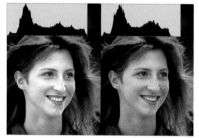

- When printing B&W images, set the black point to ensure some areas of pure black. Areas of near black with

| A portrait with "full" contrast | A portrait without pure white values |

detail often appear to be merely dark gray. Adjust your black input value such that a larger area of the image are printed purely black.

- When printing color images, set the B&W levels to ensure printing with detail; color images often do not need pure black or pure white pixels.

Easy Dodging and Burning

This is a common and easy technique for mimicking the process of two traditional darkroom techniques – dodging or burning. Dodging results in lightening part of the image; burning results in darkening part of the image. Dodging and Burning also affect local contrast; dodging a light area of an image

will reduce the local contrast, burning a light area of an image will increase it; the converse applies for dark areas. This technique uses an image layer filled with gray pixels and set to use the "overlay" blending mode; the layer can be locally painted lighter for dodging, and darker for burning.

You could do dodging and burning on a single layer, but you should consider separate layers for each part of the image that you edit; this makes changes to these edits at a later time easier.

Dodging

1 Create a New Image Layer; **Layer>New>Layer...**. Name it "Dodge"; change the blending mode to "Overlay", and check the option to fill with Overlay-neutral color (50% gray).

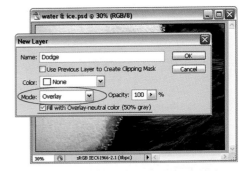

2 Change the foreground and background colors to the default; White and Black; press the D key. Your foreground color should now be white. Choose the paintbrush tool, set the brush's opacity to a low value: 10–30%. Remember that you can change the size, edge hardness, and opacity of the brush easily using the keyboard (see Paintbrushes on page 26).

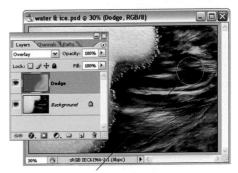

Paint with a white paint brush with a low opacity over the image to dodge

3 Paint the area of the image that you wish to Dodge.

4 If the edges of the dodge layer are too obvious, you can blur the dodge layer using the Gaussian Blur filter.

Burning

1 Create the same type of layer as for the Dodging Layer – Create a New Image Layer, Name it "Burn"; change the mode to "Overlay", and check the option to fill with Overlay-neutral color (50% gray).

2 Change the foreground and background colors to the default colors; White and Black. Switch the foreground and background colors to make the foreground color Black. Choose the paintbrush tool, set the opacity for the tool to a low value 10–30%.

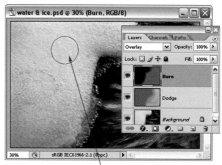

3 Paint the area of the image that you wish to Burn.

Paint with a black paintbrush with a low opacity over the image to burn

Curves Adjustment Using Locking Points

I often want to make small adjustments to a particular range of tones in a part of an image – usually to increase the contrast between these tones, but I don't want to change most of the adjacent tones. This can be done easily by "locking" the adjacent tones first, before making the curves adjustment.

Create a new Curves adjustment layer – the curve you create will affect the entire image, but focus just on the part of the image that interests you and we can localize the effect of the curve later.

With the curves dialog open, click and drag the mouse around on the various parts of the image – a tone point will move on the curve in the dialog to display the various tones for these parts of the image.

In this example, I want to add some contrast to the clouds, but I want to preserve all of the other tones in the image. The clouds have most of their tones around the ¼ tones of the image.

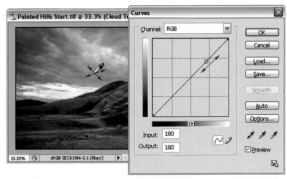

Drag the mouse pointer over the image, a tone point on the curve will show the tones for the pixels under the pointer

For tones in the image that you do not wish to change, ctrl / ⌘ +click on these tones to create "lock" points on the curve; these points will remain unchanged. Repeat to cover all the tones that you wish to protect. These lock points on the curve will assure that these values will be unchanged by this curve adjustment. In this example, I place lock points on the dark hills and the bright open area in the sky.

ctrl / ⌘ + click on tones in the image that you want to prevent from changing. This creates points on the curve that will not be moved.

Now you can go to the tones that you wish to change and ctrl / ⌘ +click to

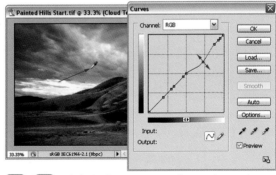

ctrl / ⌘ + click on the image to make a point on the curve and adjust the point to edit the tones for this point

create a point within these tones but now go ahead and move the point on the curve to change the tones. This can be done easily using the arrow keys. Typically, I just experiment by moving the adjustment point around to increase the local contrast.

Hit OK to close the curves dialog.

You may now wish to localize the effect of this curve to only a certain area of the image. Do this by painting on the mask for the curve adjustment layer.

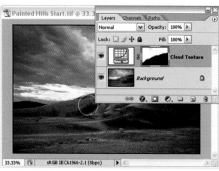

Paint on the adjustment layer mask to further localize the curves adjustment

Contrast Masking

Contrast Masking is a technique that is typically used in the darkroom to reduce the contrast of a print and make it fit within the tonal range of photographic paper, but it also has the added benefit of increasing highlight and shadow detail, and increasing apparent sharpness. **Contrast Masking is especially useful for reducing the contrast of an image while maintaining sharpness** – a good contrast mask keep the image from looking mushy when reducing contrast; reducing contrast using the curves tool often results in a flat, unappealing image.

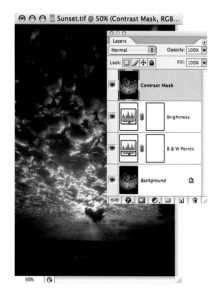

1 Create a new Merged Image layer on which to perform the Lens blur (page 24). If you only have a *background* layer, duplicate it by selecting **Layer>Duplicate Layer...**. Name this the "Contrast Mask" Layer.

2 Desaturate the contrast mask layer; **Image>Adjust>Desaturate**. This converts this layer into a monochrome image.

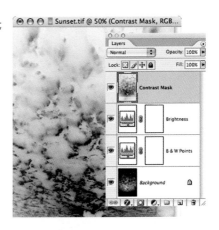

3 Invert the contrast mask layer; **Image>Adjust>Invert**. This turns the contrast mask into a negative of the original image. The same basic idea of a traditional contrast mask.

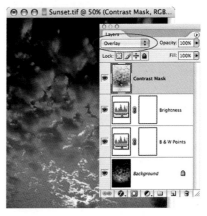

4 In order for this mask to affect the original image, we need to blend it with the lower layer. Change the blending mode of the contrast mask layer to "overlay". This brings detail back to the highlights and the shadows. The change in contrast is apparent, but overall the image appears flat in areas.

5 If we soften the contrast mask, we can restore some of the original detail of the image, in fact, this acts as an unsharp mask, increasing the local contrast and making the image appear sharper. Select the contrast mask layer and blur it; **Filter>Blur>Gaussian Blur**. The amount of the blur depends on the image; adjusted to the

maximum value that still retains the increase in shadow or highlight detail. For this image, I used ~10 pixels.

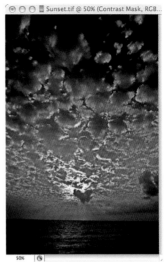

Shadow/Highlight Tool

After making the full range of tonal adjustments to an image, the result has good overall tone, but the Shadows and/or Highlights may have become compressed resulting in flat Shadows or Highlights with little detail. The Shadow/Highlight tool is an effective and easy tool that allows you to restore some of the contrast within the Shadows or Highlights without making significant changes to the overall tone that you have carefully adjusted. The Shadows/Highlight tool is able to determine the areas of the image that contain Shadows or Highlights and edit the local contrast within these areas. The only big limitation of the Shadow/Highlight tool is that it is not available as an adjustment layer; so you will need to make a Merged Image layer on which to perform the Shadow/Highlight adjustment.

For my example image, I will want to make adjustments to both the Shadows and Highlights. If you want to make adjustments to both, I suggest that you perform the Highlights and Shadows adjustments on separate layers so you can change these independently later. I'll start with the Highlights in this example.

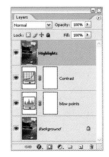

First create a new Merged Image layer on which to perform the adjustment. Hit ⌘ / ⌥ / *Shift* +E or *ctrl* / *alt* / *Shift* +E. Change the name for this new layer to "Highlights". See page 24.

Open the Shadow/Highlight tool by selecting
Image>Adjustments>Shadow/Highlight….

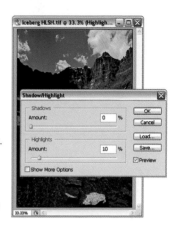

First change the values for both Shadows
and Highlights to zero; the default values are
generally way too high. Adjust the value for
Highlights to add some detail to the highlights;
typically, a value between 2% and 10% is sufficient.
Usually that's it. Hit OK to close the dialog.

If you set the value of
highlights to a value of 10%
or more, the adjustment
may result in some minor
color changes in the image.
Change the blending mode for the "Highlights"
layer to luminosity – this eliminates the color
changes.

Create another Merged Image layer for the
Shadows, and perform the adjustment again to add
detail to the Shadows. Again the best range for this
tool is usually a range between 2% and 10%.

Restoring detail to the Shadows and Highlights
often results in a more natural looking image with

a smoother range of tones from black to white.

The Shadow/ Highlight tool includes more
advanced options for adjustments. Selecting the
"Show More Options" check box opens these
advanced options.

The **Amount** option is the same option set in the
basic dialog, it determines how strongly to apply the
Shadow or Highlight adjustment. A large amount will
lighten shadows or darken highlights more strongly.
Typically, this should be between 2% and 10%.

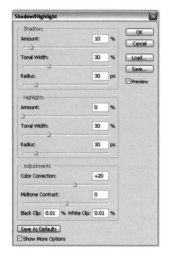

The **Tonal Width** option controls the range of tones that are defined as Shadows or Highlights. Again, the default value of 50% is too high; this implies that the Shadows are the 50% darkest pixels in the image. Typically, a range between 20% and 40% works well. I usually set this to 30%.

The **Radius** option defines the how far around a given Shadow or Highlight pixel will be affected by this adjustment. This option helps localize the affect of this adjustment to the regions of the image that have shadows or highlights. Typically, this value should be large for an image with large areas of shadows or highlights, and small for an image with smaller areas. I typically leave the radius set to 30, but I will adjust the value for images that have particularly large parts of the image that I want to adjust by the shadows or highlights.

If you make changes to these advanced options, you can save these as the defaults by clicking on the Save As Defaults button.

Before the Shadow/Highlight tool was added to Photoshop, I used an unusual curves adjustment layer to perform a similar adjustment. The steps for my Shadow/Highlight adjustment are included on the website.

Advanced Options – Color Corrections

Color matters – very small changes in color can create strong overall changes in your image. This is especially true for subtle colors, colors that are near to neutral gray and colors that complement each other within the image. There are lots of techniques for correcting color precisely within your images, yet often the final judge for the quality of the image is your own eye.

For any subtle color corrections, you need to depend on your monitor to show you your images accurately; make sure you have your monitor calibrated.

Look at images that have good color. I still often use the colors of other images to help me adjust my work. You can go to the website for any stock agency and search for images that are similar to your image. Adobe Stock Photos is built right into Adobe Bridge and Adobe Bridge makes it easy to copy accurate comps into Photoshop for comparison. Remember, good color is not necessarily accurate color; good color serves your design goals. But be careful, modern photographic design includes some fairly unusual color casts; usually, stock images either have accurate color or very unusual colors.

I have listed several adjustments that I commonly use to fix color in my images. I seldom use the Color Balance tool provides in Photoshop. I think the most useful is using the Auto Color options within a Curves adjustment layer – learn this technique, it is quick and easy, and it usually creates acceptable color in one adjustment. Experiment with the other technique in the section, they are each useful for various problems with editing color.

The Tasks for Using Auto Color and Color Correcting by the Numbers can both be performed using a Levels or a Curves adjustment layer. I use curves for the first technique and levels for the second.

Using Photoshop's Auto Color

Photoshop provides a tool for automatic color correction; the Auto Color option is available on the **Image> Adjustments** menu, but this only works occasionally. Here is a more powerful way to use this tool.

1 Examine the image for a color cast.

2 Create a new Curves adjustment layer; **Layers>New Adjustment Layer>Curves**, name this the "Auto Color" layer. The Curves dialog contains a button for Auto Color correction, and a button for Auto Color Correction Options; Select the Options button.

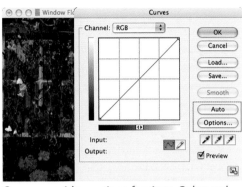

Curves provides options for Auto Color and Auto Color options

3 The default Auto Color Correction options are not the most effect options; they mimic the Auto Levels command that can produced odd; but these options can be adjusted to be more effective.

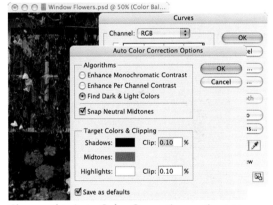

Change the Auto Color Correction options to better defaults for color correction

First, select "Find Dark and Light Colors" and "Snap Neutral Midtones"; this sets the color correction options to Auto Color. For some cases this works fairly well.

Second, set the Target Clipping values to "0.00%" for both the Shadows and Highlights; it is not necessary to clip any pixels in the color balance step, this is best done when adjusting highlights and shadows. Check "Save as defaults". You won't have to reset these when you enter this dialog again.

Often, this is good enough. The image window will show a preview using these Auto Color settings.

4 Often, the Auto Color Correction improves the color, but still does not properly color balance the image. One step to improve this is to set the Target Color for the Midtones. By default, Photoshop tries to lock the middle tones to an exact Gray value, but sometimes these middle tones should actually be a slightly different color near gray.

Click on the gray box for the Midtones Target Color, this brings up the Photoshop Color Picker.

5 Change the target midtone color to a color that provides for a better overall color balance. Set the "B" (brightness) to 50 to make the Color Picker display a field of neutral colors.

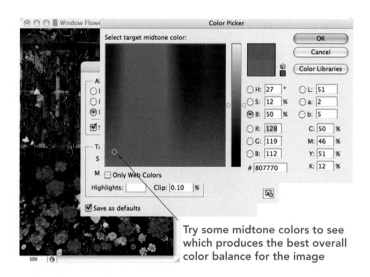

Try some midtone colors to see which produces the best overall color balance for the image

The color field will now show a full range of neutral colors, try selecting some colors that you feel the image needs to shift towards; just click around in the color picker and the image will show a preview of your image. Once you have picked a neutral color that makes your image look good, press OK to accept your color from the Color Picker, and OK to accept the Auto Color Correction options.

The image should now have a fairly good color balance; this process works well for a majority of images, but there are still some images that will require manual color correction.

Color Correction by the Numbers

Often it is more precise to color correct using numerical values rather than visually. This is especially useful when you have something in the image that should be gray or neutral; a color is neutral if the Red, Green, and Blue (RGB) values are all equal. If you have an image that contains something that should be neutral; use this technique. Ideally, you might have something bright that should be neutral (like a cloud, or a white dress) and something middle toned that should be neutral (like concrete or other stone).

1 Examine the image for a color cast. We can use the color sampler tool to measure the precise values of individual colors in the image.

2 Select the color sampler tool. It is hidden under the eyedropper tool on the toolbar. It looks like the eyedropper tool with an added target.

3 We want to sample more than just a single pixel at a time in order to get a more accurate measure of the colors we are sampling. On the options toolbar for the color sampler; change the sample size to "5 by 5 Average".

4 Select the Info palette, it is likely docked with the Navigator palette.

5 As you move the color sampler tool over the pixels of your image, the numerical value of the pixels is displayed in the info palette.

6 Examine the image for a good highlight, and midtone area of the image. For this exercise, these should be areas that you want to be **neutral toned**. If your image does not have a neutral toned highlight, or midtone area – you cannot color correct for that range within your image; this process is still effective if used for only one range. If you try and make a non-white area white, you can completely throw off the color balance of the image.

7 We can set fixed points onto the image to show in the info palette. To do this, just move the color sampler over the desired pixels and click on the image. A selection point will be placed on your image and a new point will appear in the info palette.

8 Select a white point for #1, and a gray point for #2. In this example, I placed point #1 on a white flower, and point #2 on the window curtain.

9 If we look closely at these numbers, we can see that the white point is not really white; the R, G, & B values are not identical.

10 Create a new Levels Adjustment Layer; **Layers>New Adjustment Layer>Levels**. Name it "Color Correction".

Place color sample points on something that should be white and something that should be gray

11 Correct the values for the white point first. We'll use the white eyedropper tool for this. Examine the values for the white point and pick the R, G, or B value that is highest in this case 249; we will change the value for this point so that the values for R, G & B are all 249, this making the point neutral and near white.

12 Double-click on the white eyedropper to open the color picker tool; in the R, G, B values, enter the *highest* value of R, G, or B for

the white point into all of the RGB values – making all of the values the same. Close the color picker tool.

13 In the levels dialog, select the white eyedropper and click on the white point in the image. This forces the white point to become the same as the value we entered in the color picker tool.

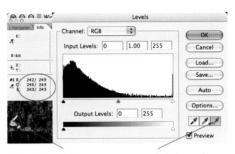

Select the white eyedropper and click on the white sample point to adjust the white value you set in the color picker. The Layers tool adjusts the three channels to make it white.

14 Lastly, we need to set the neutral point. We can do this using the midtone eyedropper, but this often throws the values of white and black off. So we will make this adjustment manually. For the neutral point, we want to adjust the values of RGB at the neutral point to be the same as the middle value for R, G, or B (this changing the tone of the image least, but obtaining a neutral value). Determine which color needs to be increased (in this case the Red channel) change the channel in the Levels dialog to this channel (Red) and slide the middle input slider to adjust it until it is the same as the neutral value.

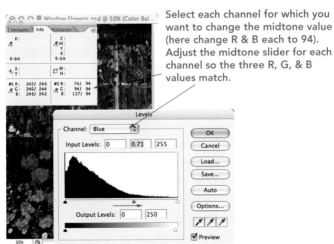

Select each channel for which you want to change the midtone value (here change R & B each to 94). Adjust the midtone slider for each channel so the three R, G, & B values match.

15 Then change the Channel in the Levels dialog to the color that needs to be reduced (in this case the Blue channel). Slide the middle, gray input slider to adjust it until this color is the same as the neutral value.

The midtoned point should now be a neutral color. Press OK to close the Levels dialog.

Color Correcting Skin Tones

When color correcting an image, there are often specific colors within the image that need to be precisely defined; often these are near white, near black, or gray colors, all of which are relatively easy to color correct; but one color that usually needs to be corrected most precisely is skin tone. Skin tones can be fairly subjective to correct, but there are some strategies you can use to precisely match skin colors (this technique is partially based on steps in Katrin Eismann's book, see the Appendix).

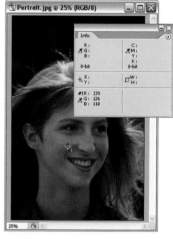

1 Examine the image and make some basic evaluation of the color cast.

2 Select the color sampler tool. Use it to place a sample point on the subject's skin; use a patch of skin that you will want to be perfectly color balances; avoid the shadow side of the skin. Now open the info – note the RGB values.

3 What are the correct RGB values for skin tones? I have created a skin tone gradient that mimics skin tones fairly well. In general, red is the strongest value for most skin tones; at the lightest and darkest extremes; Green is 90% of Red, and Blue is 80% of Red; for moderate skin tones (including most Caucasians); Green is 76% of Red and Blue is 52% of Red.

This map has worked fairly well for getting my skin tones close.

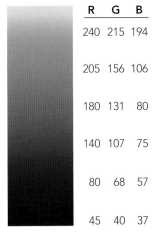

R	G	B
240	215	194
205	156	106
180	131	80
140	107	75
80	68	57
45	40	37

4 Another good option for obtaining correct values for skin tone is from other images that appear to have good color. This allows you to select a sample subject that is similar in tone to the subject in the original image. I usually go to an online catalog of stock photography, select the **People** category and start browsing through the CDs for an appropriate image. Here are some sample skin patches.

5 Now that you have appropriate values for the skin tone, you can correct to these values in the same way as correcting for white, black, or gray tones.

Create a new Levels Adjustment Layer, name it "Color Correction".

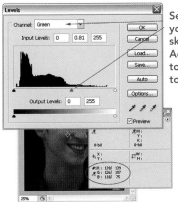

Select each channel for which you want to change the skintone value (here G & B). Adjust the midtone slider to set the R, G, & B values to good skintone values.

You just need to set the values for the skin tone point to match the desired values for this skin. In this case, the point is currently at 139/126/118 (too green and too blue); based on my skin tone gradient, this should be changed to 139/107/75.

In the Levels dialog, set the channel to green, and adjust the midtone slider until the green value for the sampled point is shifted to 107. Do the same for the blue channel until the blue value is 75.

Copying Color Corrections

There are many times where you might wish to apply the same color correction to a number of different images. This generally happens when you have a number of images that were shot under very similar conditions, so that the same color balance will work well for all these images.

It is possible to just copy a color correction adjustment layer (or any layer) onto another layer merely by dragging from the source image and dropping the layer onto the destination image. You can also copy a layer from one image to another by selecting that layer in the source image and using the 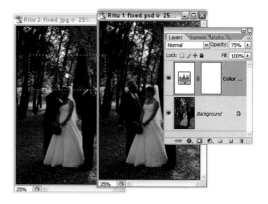 **Layer>Duplicate Layer** command; in the **Duplicate Layer** dialog, change the Destination Document to the destination image.

Just copying a color correction layer from one image to another works for color corrections that use an adjustment layer and that adjustment is active everywhere (the mask is white). But often the color correction may have required a number of different adjustments including masks or adjustments that have been applied to stamped image layers; these won't copy over well to a new image.

Match Color

You can copy the colors from one image to another using the Match Color tool. This tool works well for images that have substantially similar original colors; ideally colors shot from the same original source; images with very different colors tend not to match well.

1 Save the source image (the image with the correct color). Make a duplicate of this image by selecting **Image/Duplicate Image**; in the Duplicate Image dialog, select "Duplicate Merged Layers Only" to make a flattened copy; you won't need to save this file, so name it "Color Source".

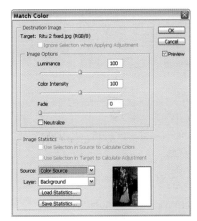

2 Open the destination image, if this image has any layers other than the *background* layer, you should make a Merged Image layer to hold the color changes made by the Match Color command (see page 24 under layers).

3 Select **Image>Adjustments>Match Color**.

Down at the bottom of the dialog; change the Source to be the "Color Source" image that you created in step 1.

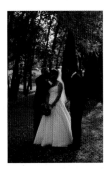

If the two images are similar originals, the colors from the source image should be mapped onto the destination image.

If you have images that have some colors that do not match, you can still use Match Color by make selections around those portions of these images that have similar colors. Make a selection around the colors that you want for your source in the source image, and the colors that you want corrected in your destination image, and then use the Match Color tool. In the Match Color dialog, you can

choose to use the selection for the Source image and/or the target image; select these to target the color changes.

Photo Filters

Often accurate color is not enough. Photographers have been using color photographic filters since the beginning of color photography to help improve the color of their images. Photoshop provides a nice and simple tool for mimicking color filters. Often the photo filters will add some snap to images that have merely adequate color.

1 Photo Filters generally work best on images that have adequate color balance already; you should try and get your color balance as good as you can using one of the traditional color correction techniques.

2 Create a new Photo Filter Adjustment Layer; **Layer> New Adjustment Layers>Photo Filter**.

3 In the Photo Filter dialog, set it to use a Filter and pick a color filter. The best filter is often the "Warming Filter (85)"; it creates a nice warming effect without being obvious. Adjust

the density to match the appropriate look, often 25% works well for the 85 filter.

4 Hit OK to close – done; a slight warming adds just a touch of extra color to your image.

The #85 warming filter is slightly orange, many photographers prefer the #81 filter that is more yellow. Experiment with the other color filters as well; these are often an easier way to create an unusual color effect.

Reducing Red in Skin Tones

Digital cameras and color film can both reproduce skin tones with too much red. It is often necessary to simply reduce some red from skin tones to make the whole image appear more natural.

1 Select the skin of the subject; the Polygonal Lasso tool is often effect here; just select the tool and click around the face. Feather this selection.

2 Create a new Hue/Saturation adjustment layer; name it "fix red in skin". Photoshop creates a mask from your selection. In the Hue/Saturation dialog, change the Edit dropdown to Reds. Reduce the saturation of the reds to improve the skin tone.

Done. More natural skin.

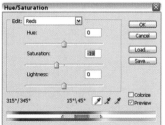

Removing Blue from Shadows

This technique can be applied to a number of similar color correction problems such as removing the excess blue in shadows.

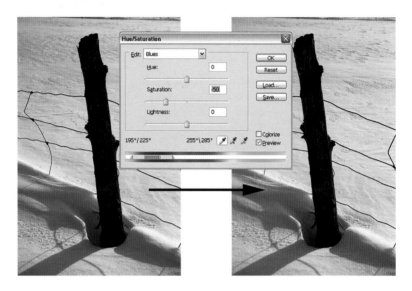

Select the shadows of the image. The Select Color Range tool works here.

- Create a new Hue/Saturation Adjustment Layer; in the dialog select the Blues from the Edit list, and reduce the Saturation for the Blues by 50 points. This removes most of the blues from the shadows, but retains some blue so the image still looks realistic.

Other options might include reducing the yellow from a tungsten light source, or removing a color caused by reflected light.

Changing Color with the Color Replacement Tool

The Color Replacement tool provides a way to change a color on part of the image quickly by painting over the color. It is a very easy tool for changing the color on a specific object within

the image. For the example shown here, I will be changing some of the red weave into orange.

1 Create a new Merged Image layer on which to paint the new color (page 24). If you only have a *background* layer, duplicate it by selecting **Layer>Duplicate Layer….** Name this layer for the color edit – here I use "Change Red weave to Orange".

2 Select the Color Replacement tool. It is under the paintbrush tool.

3 The default options for the Color Replacement tool work well for many types of images. The Color Replacement tool selects the color from under the mouse pointer and changes all the pixels within its brush to the Foreground color. Sample Once is more precise (it changes the color under the brush when you first click), but Sample Continuous is generally easier as you paint across an object. Just be careful not to paint outside of the object whose color you are replacing.

Sampling: Continuous Sampling: Once

4 Next select a color. The Color Replacement tool uses the Foreground color. You need to set it to your new color. Click on the foreground color square to bring up the color picker. Move the pointer over the image and click on the color that you will be changing. This lets you see the starting color in the color picker.

Then change the color in the Color Picker to the new color you want.

5 Close the color picker and begin painting in the image over the color that you want to change. That's it. Paint over the color enough to ensure that all the pixel are changed.

B&W Images

B&W photography continues to evolve and create its own artistic path. Yet, many image editors or designers only consider B&W images when their printing requires B&W. B&W images are already non-photorealistic images and therefore already somewhat abstract. Printing images in B&W provides great creative opportunities. **B&W images can usually be edited and manipulated in ways that would ruin color image**; the abstract nature of B&W photography automatically reduces the need for a traditional "photorealistic" image.

In the digital realm, images are rarely shot in B&W, but rather shot in color and converted to B&W; this gives you more flexibility in how individual colors are translated into various B&W tones. **If you shoot a digital camera, shoot all your images in color**. If you are comfortable shooting B&W film, definitely continue to do so. I continue to shoot many of my B&W images onto film.

B&W Images and the Digital Workflow The workflow for B&W images is essentially identical to the workflow for color images – except you won't do the color adjustments. There are a couple of differences to consider.

When you start with a color image, make sure that the color image has good density by performing the basic end point, brightness, and contrast adjustments on the color image (it is easier to convert a color image to B&W if it starts with good density). Then convert the image to B&W and start creating adjustment layers for the basic tonal adjustments.

Converting from Color to B&W – Using Luminosity

It is very simple to convert a color image into a B&W image in Photoshop by desaturating the image (**Image>Adjustments>Desaturate**) or by converting a color image into grayscale (**Image>Mode>Grayscale**) – neither of these options generally produces very good results. The classic technique for converting color images into B&W used the Channel Mixer (I have provided a document for using the channel mixer on the website). I prefer to remove the color and preserve the luminosity.

| Desaturate | Luminosity | Channel mixer |

1 Make sure the top layer in your layers palette is selected and create a new image layer above it; **Layer> New>Layer...**. In the New Layer dialog, name this new layer "Convert to B&W", and change its mode to "Color". Press OK to accept this dialog.

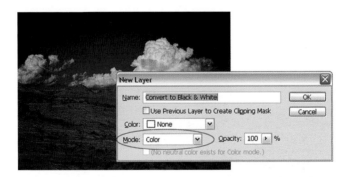

2 For now, nothing appears to happen, as the new image layer is completely empty. Fill the new layer with Gray; select **Edit>Fill...**. In the Fill dialog, select "50% Gray" for the Use option.

The Convert to B&W layer is now filled with gray, and the "Color" blending mode replaces the color of the image with the color of this gray layer, resulting in a B&W image. The luminosity of the original color image is preserved.

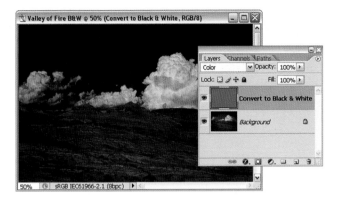

3 The basic process is complete here. But I will often experiment with the colors below the Convert layer to improve the look of the final image. Select the layer below the Convert to B&W layer and create a new Hue/Saturation layer, I usually call this the "mess with colors" layer.

Experiment with making some extreme changes to the colors by shifting the Hue. You could also experiment with a Color Balance or Photo Filter adjustment layer.

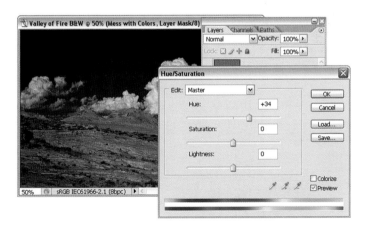

You can also make the image include some of the original color by reducing the opacity of the "Convert to B&W" layer; this is a quick trick to create a hand-colored look for your images.

Toning B&W Images

Most color printers print B&W images poorly. This can be resolved easily by toning the B&W images, essentially converting these into a color image. Some newer photographic printers are designed to print beautiful B&W images.

1 Ensure that the image is in RGB mode; select **Image>Mode>RGB Color…**.

2 Add a new Hue/Saturation adjustment layer; select **Layer>New Adjustment Layer>Hue/Saturation**; name this layer "Toning Layer".

3 Within the Hue/Saturation dialog, click on the colorize option in the lower right of the box. This converts the Hue/Saturation dialog box into a colorizing tool. Adjust the Hue for the desired color. Leave the saturation level at 25. Although this may make the colorizing effect seem too strong, the next step will reduce the effect and make a more realistic tone. Hit OK to accept the Toning layer.

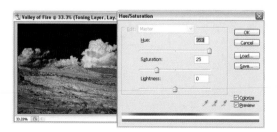

4 Change the blending mode of the layer to make a more realistic tone to "Soft Light" and the opacity to about 50% for this layer. Experiment these adjustments to get the best overall look.

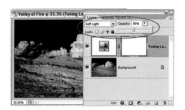

5 Print this image on your color inkjet printer. For slightly toned or moderately toned prints, the monitor will not be a very good judge of the final print tone; you will need to evaluate these prints based on the final printer prints, not from the monitor.

Photographic Effects

Film Grain

Film Grain in photographic film is due to the clumps of
silver or dye in the emulsion. It has its own important
aesthetic in photography. You may wish to add film
grain to add some abstraction to your images, create
a more classic or even dreamy appearance, and even
to mask softness or digital noise in your image.
This technique will also demonstrate how to apply
Photoshop filters that are not available in
16 bits/channel mode to 16 bit images.

1 Duplicate your image, select **Image>
Duplicate Image…**. In the Duplicate
Image dialog, name the new image
"Film Grain". If your image has more

layers than the background layer, select the "Duplicate Merged Layers
Only" option.

2 If necessary, change the "Film Grain" image to 8 bits/channel, select
Image>Mode>8 Bits/Channel. This is necessary for many of the
filters.

3 Apply the Grain Texture
filter; select **Filter>
Texture>Grain…**.

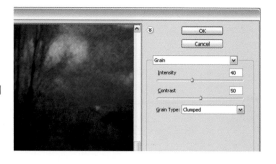

The "Clumped" Grain
Type is the best general
type. Experiment with
the settings to get the
look you want.

4 Fade the filter to reduce the color added by the grain. This is an aesthetic choice; I find that the color grain is not very appealing. Select **Edit>Fade Grain...**. In the Edit Fade dialog, set the "Mode" to "Luminosity" – this makes the added grain match the image colors.

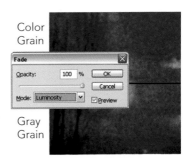

Color Grain

Gray Grain

5 Finally, copy the "Film Grain" image back onto your original image. Select **Layer>Duplicate Layer...**. In the Duplicate Layer dialog, set the name for the new layer to "Film Grain" and change the "Destination" document to be your original image. This converts the background layer of Film Grain image to 16 bits and copies it onto your original image.

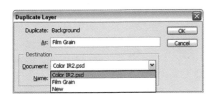

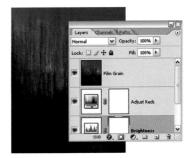

6 For a stronger antique effect, create a curves adjustment layer to add additional contrast to the image.

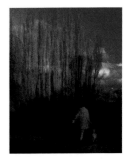

Soft Focus

Soft Focus combines a sharp version of an image with a blurred version resulting in a softer pleasant image.

Soft focus is commonly used with portraits and floral images. This steps used for this technique can be used for any of a number of filters which affect the image globally (here the Gaussian Blur filter), but for which you wish to maintain some pieces of the original image.

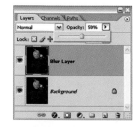

1 Create a new Merged Image layer on which to perform the blur (page 24). If you only have a *background* layer, duplicate it by selecting **Layer>Duplicate Layer...**. Name this the "Blur Layer".

2 Change the opacity of the Blur layer to 50%; this allows the Blur layer to blend with the image beneath it. The image will not appear to change, as the Blur layer has not yet been blurred.

3 Select **Filter>Blur>Gaussian Blur**. Adjust the Radius value to obtain the overall amount of blur that you wish for this image. Evaluate the adjustment based on the Image window since it shows the blur layer blending with the sharp image below it. Click on OK to accept the filter.

4 Now we have the correct Soft Focus image, but you can also restore parts of the image to their original sharp focus. Create a mask for the blur layer; select **Layer>Layer Mask>Reveal All**.

Select the paintbrush tool, make sure you have a soft brush, and set the foreground color to black. Also, set the paint brush opacity to about 50% (see page 26 on brushes). Now you can paint black onto the new mask.

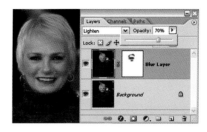

5 Paint over the areas of the image that you wish to return to the original sharpness. For portraits, try painting over the eyes, mouth, and the hair right around the face.

6 You can also experiment with the blending modes for the blur layer; try changing the layer blending mode to "lighten"; or "darken".

Lens Blur

You may have an image with a good subject but a distracting background. Use focus (or lack of focus) to separate the subject from the background and make the image stronger. The Lens Blur filter is an excellent tool for defocusing part of the image.

1 Create a new Merged Image layer on which to perform the Lens blur (page 24). If you only have a *background* layer, duplicate it by selecting **Layer>Duplicate Layer...**. Name this the "Lens Blur Layer".

2 Make a selection around the subject. Use whichever tool best suits the image. I used the Polygonal lasso to make a selection around

Chris and Seema in this image, and use Quick Mask mode to paint a soft edge in the selection along the floor. Pixels that are partially selected will be blurred less by the Lens Blur filter – the soft edge of the selection along the floor will cause the Lens Blur filter to create a smooth transition in focus.

3 Once you have a good selection, save the selection by selecting **Select>Save Selection...** provide a name for the selection that refers to the blur. After saving the selection, remove it from the image; select **Select>Deselect**.

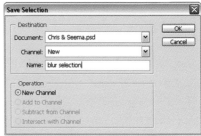

4 Select the Lens Blur filter; **Filter>Blur>Lens Blur....**

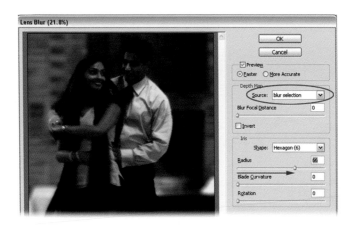

Open the Source option under Depth Map and select the selection that you saved for the blur. This defines where on the image the blur should

occur. Drag the Radius option to the right to set the amount of blur to apply to the image. More blur is often better, but a stronger blur will also make flaws in a less than perfect selection more obvious. As with many image edits, subtly is important. If the subject becomes blurred (rather than the background), check the Invert option in under Depth Map. Press OK to accept these changes.

There are many different options available for fine tuning the lens blur to provide additional options which mimic the effects of real photographic lenses.

Photo Edges

Photo Edges change the frame of the image from a ridged rectangle into an edge with more interest. Photo edges can provide additional interest to very simple images especially for images that you might wish to stand out from adjacent text. Strong, jagged edges can make the image appear more edgy; soft, smooth edges can make the image appear softer. I list instructions for making photo edges and for applying photo edges to your images. Photo edge files are generally high contrast, containing mostly pure black and pure white pixels. Don't worry if the edge is black or white, it is easy to switch this around.

Making Photo Edges in Photoshop

1 Create a new image on which to make the photo edge; select **File>New....** In the File New dialog, select an appropriate preset for the target image; 4″ × 6″ is a good frame size for a rectangular

image. Leave the new image in 8 bit per channel mode as some of the filters that you may want to use will not work with 16 bit images.

2 Select the entire image area; **Select>All**. Resize the selection to make it fit the center of the image by using **Select> Transform Selection**; hold down the [alt] / [⌥] + [Shift] keys and drag the corner of the transform box towards the center. Once the selection is the right size for the photo frame, press Enter to accept the transformation.

3 Fill the new selection with Black; set the colors to the default colors B&W by pressing the D key, and fill the selection with the foreground color by pressing [alt] / [⌥] +backspace.

4 Remove the selection; **Select>Deselect**. This allows the filter to apply to the entire border layer.

5 Select **Filter>Brush Strokes>Spatter**. Experiment with the settings. Press OK to accept the filter. Many of the filters can be effective for creating interesting borders. Try the Glass, Ocean Ripple, Sprayed Strokes, or Torn Edges filters. Further experimentation can create some interesting edges.

Making Real World Edges

A good option for making interesting photo edges is to create edges in the real world, and then scan these into the computer to create digital versions. Good options for real world objects include torn paper, painted edges, images from negative carriers, and edges from Polaroid film. Just tear, paint, print, and expose to make these objects and scan them into the computer to create a digital file.

Polaroid edge Painted edge

Once you have a digital file, use the Levels tool to set the B&W points on these images so that most of the image pixels are pure black or pure white.

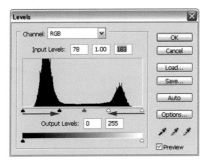

Applying Photo Edges to Images

Once you have an appropriate photo edge file, it is very easy to apply the photo edge to an image.

1 Open both your image file and the edge image file that you want to use. If necessary, rotate the edge image to match the orientation of the image file by selecting **Image>Rotate Canvas>90° CW**.

2 Select the edge image and move it onto your image file as a new layer by selecting **Layer>Duplicate Layer...** In the Duplicate Layer dialog, name the new layer "Edge", and change the Destination document to match the target image file.

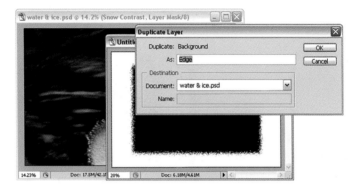

3 The edge will likely be smaller than your target image. To resize the edge, select **Edit>Free Transform**. Drag each of the handles of the transform box out to the corners of the image so that the edge layer now covers the entire image. Press OK to accept the transform.

4 Finally, change the blending mode for the Edge layer to "Screen". This makes the edge layer transparent where it is black, thus making the original image visible through the center of the image.

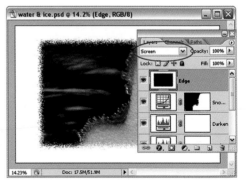

5 This example produced a white edge around the image. To make a black edge, select the Edge layer and invert it by selecting **Image> Adjustment>Invert**.

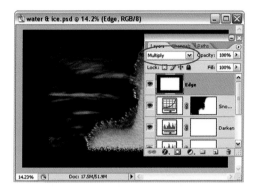

Burn Corners

A traditional darkroom technique is to blur and/or darken the corners of an image by burning the corners. This helps draw the attention of a viewer towards the center of the image. These steps mimic the results of burning.

Blur Border

1 Create a new Merged Image layer on which to perform the blur (page 24). If you only have a *background* layer, duplicate it by selecting **Layer>Duplicate Layer...**. Name this the "Blur Corners".

2 Create a border mask for the "Blur Corners" layer. Pick the Elliptical Marquee tool form the toolbox and draw an elliptical selection over the image, then select **Select> Transform Selection** to get the selection placed precisely.

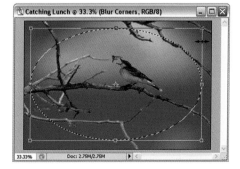

3 Create a mask for the "Blur Corners" layer from this selection that reveals the corners outside of the selection. Select **Layer>Layer Mask>Hide Selection**.

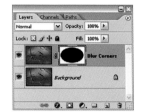

4 Now blur the new layer. Select the image part of the "Blur Corners" layer by clicking on the image thumbnail. Use the Gaussian Blur filter; select **Filter>Blur>Gaussian Blur**. Experiment with the blur radius to get a good effect on the edges.

5 The blur effect is now visible, but the transition from sharp to blur is very abrupt. This can be fixed by blurring the mask itself. Select the mask of the "Blur Corners" layer and blur the mask as well using Gaussian Blur.

6 The edge of the diffusion is now much softer. The effect may still be too strong. Reduce the opacity of the "Blur Corners" layer to turn down the effect.

Darken Border

The darken border is very similar to the blur border, but an adjustment layer is used rather than an image layer. This works well for darkening the image corners.

1 First create a selection for the mask that will be applied to the adjustment layer. I again use an elliptical selection for this image. Use **Select> Transform Selection** to get the selection placed precisely.

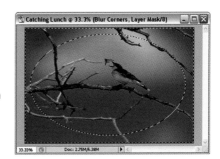

2 Invert the selection so that it now selects the Corners of the image; **Select>Inverse**.

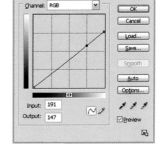

3 Now applied the desired adjustment. The most general adjustment for darkening the corners is the curves adjustment. Create a new Curves Adjustment Layer; **Layer> New Adjustment Layer>Curves...** Name this "Darken Corners".

4 Adjust the curve to darken the edges of the image. This curve assures that there are no highlights around the edge of the image. The selection of the corners was automatically converted into a mask for this new adjustment layer.

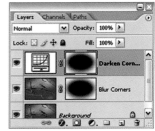

5 The darkening is now visible around the corners, but the effect is applied very abruptly around the image. This can be fixed again by blurring the mask itself. Select the mask for the "Darken Corners" adjustment layer and blur it; **Filter>Blur>Gaussian Blur**.

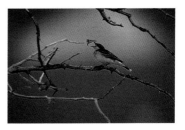

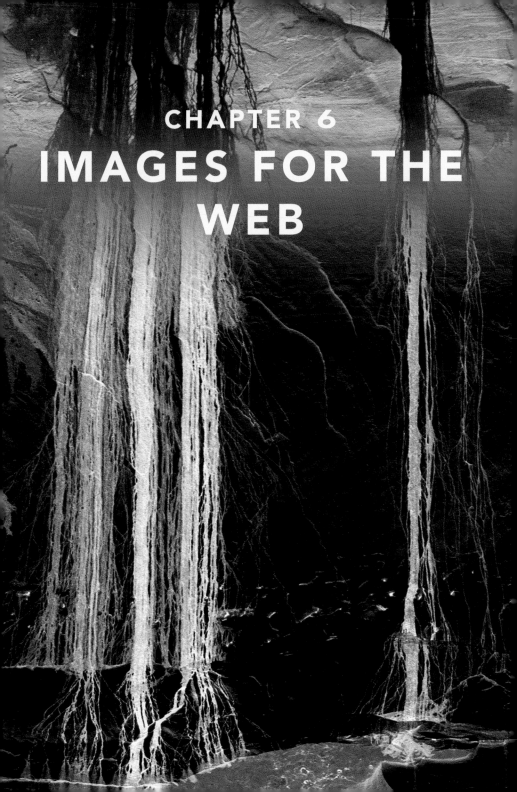

CHAPTER 6
IMAGES FOR THE WEB

Today, more images are placed onto the web than printed. The web has become a primary medium for communication, and images are as important on the web as they are for any print media. This chapter covers some considerations for web images, and provides some tasks useful for creating images for the web. It does not describe the entire process for creating web sites nor for creating complex web elements like rollovers and buttons; I am certainly not the one to provide this level of instruction, and these topics would certainly require much more space than these few pages.

It is important for anyone involved in image creating and editing to know a few essential tasks for targeting images to the web. Some of these tasks can be done in a trivial way, such as creating an image to e-mail, but following a few basic steps can help make the images look better. Some tasks, like creating thumbnail images, are often handled by automated tools that can make a mess of a good image. And some of the tasks are commonly handled by web designers using image editing tools that have features that are useful to web pros but lack the imaged editing power of Photoshop.

Even if your work is not targeted for the web, review these tasks, since it is certain that at some point your images will be posted to the Internet. And you want control over how they get there.

Lastly, the digital world is fairly ignorant about color. Adobe is one of the few companies that provide real color management solutions. Very few computer applications provide any color management or implement color management well. If you intend to use your images for traditional office or consumer publishing applications, you should follow the tasks listed in this chapter.

Issues for Web Images

The following issues should all be considered when creating images for use on the web (or for use with most typical office applications). Images should be precisely resized, resized with a sharp tool, sharpened, and saved in the sRGB color space.

Precise resizing Most programs used to create web pages and web browsers are optimized to render images quickly rather than accurately. If you provide an

image to a web designer that must be resized, or worse, if you place an image on a web page that is resized by the browser, some awful results can occur. Resize your images to exactly the right size that it will be used on the web. My web designer provides me with a set of standard sizes for my images that I use.

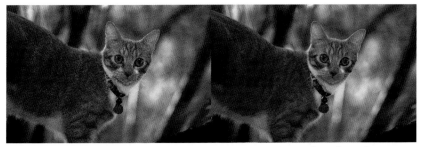

<table>
<tr><td>Image resized in Browser</td><td>Image resized in Photoshop</td></tr>
</table>

Bicubic Sharper interpolation Photoshop CS and CS2 provide new options for interpolating pixels when resizing images. The Bicubic Sharper option is especially good for web images. When working with web images, it is best to configure Photoshop to use Bicubic Sharper as its default interpolation method.

1 On Windows, select Edit>Preferences>General

On the Mac, select Photoshop>Preferences>General to access the Preferences Dialog

2 Set the Interpolation Option to "Bicubic Sharper"

Bicubic Sharper will now be use whenever Photoshop resizes an image

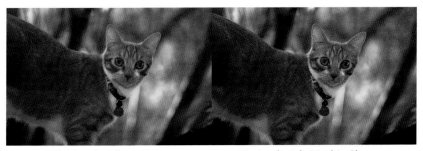

<table>
<tr><td>Resized with Bicubic</td><td>Resized with Bicubic Sharper</td></tr>
</table>

sRGB The Web uses images in the sRGB color space. If your RGB working space is Adobe RGB or another color space, then you will need to convert all of your images to sRGB before saving them for the web. This is essential, since your Adobe RGB images will appear flat when they are displayed on the web.

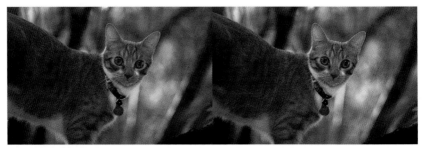

Adobe RGB image on the Web sRGB image on the Web

See the section on Color Spaces and the steps for converting to sRGB in the Printing chapter.

File size Web files need to be small and still render a high quality image. The Jpeg file format provides an excellent compromise between size and quality. Use Jpeg files for your web images, and be willing to use the moderate quality settings that allow your files to be very small.

 Web Images should be resized to their exact final dimensions; be resized using "Bicubic Sharper"; be in sRGB color space; and be saved as Jpeg files.

Creating an E-mail File

E-mail files are generally created to send a file so that it can be viewed on a computer screen. These images should be small enough so that they can be viewed on a typical computer but still large enough to show sufficient detail. Also, most E-mail systems have a limit on the size of attachment of about 1–2 MB; this limits the size and number of files that can be sent.

1 Duplicate your image file (this preserves the layers and color space of the image file). Select Image>Duplicate Image. In the Duplicate Image dialog, provide a useful name and check the "Duplicate Merged Layers Only" option.

2 If necessary convert the E-mail image to sRGB using Edit>Convert to Profile. See Convert to sRGB on page 107.

3 Resize your image; select Image>Image Size. In the image size dialog, set the resolution to 72 pixels per inch and set the Pixel Dimensions to your specific desired pixel size by changing the Width or Height. For a typical E-mail image, set the longest dimension to 500–800 pixels.

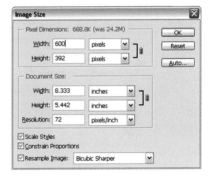

4 Sharpen the image by selecting Filter>Sharpen>Smart Sharpen. Set the Amount to 50%, the Radius to 1 pixel, Remove to "Lens Blur" and check the More Accurate option. Use a Radius of 1 pixel for web images. Sharpen smaller image files less – too much sharpening can make small files appear blocky.

5 Save the Image to the Web by Selecting File>Save for Web. In the Save for Web dialog set the File Settings; set the file format to "JPEG", the quality to "High", turn off Progressive and turn on ICC Profile. The File Information will display the file format and file size, a file size under 100 K is good for E-mail files.

Press the Save button and Photoshop will provide you a Save As dialog to save the file.

6 It is possible to resize an image in the Save for Web dialog directly rather than doing this using the Image Size dialog in step 3 above. Select the Image Size tab in the Save for Web dialog and provide size dimensions as you would using the Image Size dialog. I prefer to resize my E-mail images first, then sharpen, and then save the Jpeg files.

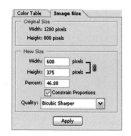

Preparing Images for the Web

Images for Web pages are very similar to images for E-mail. But generally, images for the Web need to be saved to very specific dimensions.

1 Duplicate your image file (this preserves the layers and color space of the image file). Select Image>Duplicate Image. In the Duplicate Image dialog, provide a useful name and check the "Duplicate Merged Layers Only" option.

2 If necessary convert the E-mail image to sRGB using Edit>Convert to Profile. See Convert to sRGB on page 107.

3 Select the Crop tool from the Toolbox. Set the Crop tool options to the specific width and height specified to place the image on the web page. It is important to enter "px" along with each pixel value, or the crop options will be set to your default units (inches or cm). Set the resolution to 72 pixels per inch.

4 Use the Crop tool to draw a crop marquee over the image, the Crop tool options values that you set will restrict the crop marquee to one proportion. When you have the marquee position properly, press Enter to accept the crop and Photoshop will resize the image to the target size. Photoshop will use the default resize algorithm; "Bicubic Sharper" if you have set it.

5 Sharpen the image using the Smart Sharpen filter.

6 Save the Image to the Web using the Save for Web dialog as you did for saving E-mail files above. One significant difference, many images for Web pages are save using the Progressive option. When progressive images are placed on a web page,

these images appear very quickly at a low resolution and become sharper as they download. This is a good option since it allows the web page to display quickly, even if there are many image files on it.
I typically use this option.

Thumbnails The steps for saving Web images can also be used for creating Thumbnail images for the web. It is very important to set default resize algorithm to "Bicubic Sharper" since it makes a significant difference for small images.

Thumbnail resized with Bicubic Sharper & Bicubic

Adding a Black Border and Drop Shadow

You will often need to add a simple border and/or a drop shadow to your images in order to separate them from the background of a web page.

1–5 Follow the first five steps above to prepare an image for the web.

6 Make a selection around the entire image; **Select>All**.

7 Add a fine black trim line around the image, select **Edit>Stroke...**
This is a simple effect for many images that provides a simple trim line around the image that can make it more formal and act as a boundary for the image.

8 The image has been resized precisely for your web page, but you need to make it smaller in order to fit a shadow under it. Use the Image Size dialog to change the size to 95% of the current size.

9 If your image has only the
background layer, you will need to
turn it into an image layer to apply
the drop shadow effect. Double-click
on the *background* layer,

a New Layer dialog will appear, leave the name as "Layer 0" and press OK.
You now have one image layer.

10 Make some room around the
image for the drop shadow by
increasing the canvas size; select
Image>Canvas Size. Press the
button for the upper left corner;
this makes the canvas grow to the
lower right. Enter the values
required for the final full sized
image used in step 3 above so
the image can be placed on the
web page unsized.

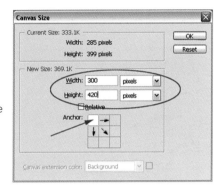

11 Add a Drop Shadow; select **Layer>Layer Style>Drop Shadow...**

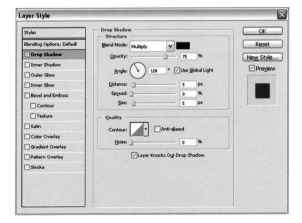

The default values are good for adding a drop shadow to a web image. But make sure that the Angle points to the upper left so that the shadow will cast down to the right. A value of 120° works well. Press OK. The drop shadow should now appear.

12 Finally, add the appropriate background color and flatten the image. You should use the same background color as your web page. If the background color is not the default color white, click on the background color patch and set the appropriate color in the Color Picker.

Flatten the image by selecting **Layer>Flatten**. The image and the shadow will be flattened onto the selected background color.

APPENDIX

Monitor Profiling

You must set up a good work environment and profile your monitor so that you can accurately view the images you are editing in Photoshop.

Work Environment

Light Work with subdued and consistent lights. Overly bright lights make the monitor appear dim and reflect light off the monitor. Dim lights can make the monitor appear overly bright and lead to eye fatigue as they move from the monitor to adjacent objects. Variations in room light will also change the appearance of images on your monitor. Standard 60–100-W tungsten bulbs are good room lights. You will also need a

A monitor hood is effective at blocking room light

good, bright light for viewing your prints near your monitor. See section "Components of a Good Print" on page 108. You can also keep reflected light off of your monitor by buying or making a monitor hood.

Colors Use boring, gray colors for your computer desktop. You should set the colors of the computer screen to be mostly neutral (grays, black and white); vibrant colors on the monitor make it difficult for you to accurately perceive colors.

On Windows, open the *Display Properties* from the control panel; set the Appearance to Windows XP style and the Silver color style.

On Mac OSX, run the System Preferences app and select the *Appearance* preference. Choose the "Graphite" appearance.

Gray color schemes

Finally, keep overly vibrant and distracting colors away from your direct field of view. Your walls don't need to be flat gray, but avoid hot pink. (Many professions do use light gray walls.)

The colors of your work environment are more important than the specific adjustments for your monitor.

Elements of Monitor Profiling

There are three basic elements of monitor calibration.

Calibration You need to configure your monitor itself to the best settings for brightness and color. A well-calibrated monitor does a good job of displaying colors; the monitor profile will only need to make small adjustments to a well-calibrated monitor. To calibrate your monitor, you will need to use the controls on the monitor itself to adjust brightness and color. Find the monitor manual if you don't know already how to do this.

Set the target color and contrast The monitor can mimic the color and contrast of a variety of light sources. You should set your monitor to mimic daylight. These values are referred to as the White Point and the Gamma. All the monitor profiling tools require you to set these.

Set the White Point to: 6500K, D65, or Daylight. (These are all the same value.)

Set the Gamma to: 2.2, Windows or TV Standard. (Even on a Mac.)

White point:	Medium White (6500)	▼
Gamma:	2.2 - Recommended	▼
Luminance:	140 - LCD recommendation	▼

Monitor calibration utilities will need to set the "White Point" and the "Gamma". Hardware tools will also help set the monitor's "Luminance" (brightness).

Profiling Profiling requires a software utility to display colors on the monitor and provide a way to correct these colors. The best solutions also use a hardware sensor to measure the colors displayed by your monitor and create the profile.

Turn on your monitor and let it warm up for 20 minutes before profiling it.

Options for Profiling

Software profiling – Windows Adobe® Gamma is a utility for profiling your monitor visually. It is installed with Photoshop. Run it from the Windows control panel. Adobe Gamma can be run in a "step-by-step" mode that eases the process. Adobe Gamma will help you calibrate your monitor, so you will need to be able to adjust the monitor brightness.

As you walk through the Adobe Gamma, you will be asked to set the White Point and the Gamma; use 6500K and 2.2 as described above.

Adobe Gamma will also ask for the Phosphors of your monitor. This throws most users. Your monitor is likely to use Trinitron or P22-EBU (typical CRT monitors). There are no options listed for LCD monitors. Adobe Gamma does not work well on LCD displays; use the Trinitron option for LCD displays, but realize that the results may not be great.

Once you run through Adobe Gamma, you should see a difference in the color of your monitor. Run through it again to see if the color changes with a second try. It can be difficult to calibrate with type of utility.

Software profiling – Mac Apple provides the Display Calibrator Assistant for profiling the monitor. Select the Display preferences from the System Preferences. Select the Color tab and press Calibrate to access the Calibrator Assistant. This tool is very similar to Adobe Gamma; but as an integrated system, the Calibrator Assistant can calibrate the monitor color and brightness for you. The basic mode merely requires that you supply target values for White Point and Gamma; use 6500K and 2.2 as described above. The expert mode provides a five-step wizard to help profile the monitor.

Once you run through the Calibrator Assistant, you should see a difference in the color of your monitor. Run through it again to see if the color changes with a second try. It can be difficult to calibrate with type of utility.

Hardware profiling It is also possible to buy a hardware sensor (known as a puck or spider) that can be attached to your monitor to measure the displayed

colors. These sensors work with a wizard that is similar to the software utilities described above, but measure the output color values more precisely that the "eyeball" technique. The result is a very accurate monitor profile.

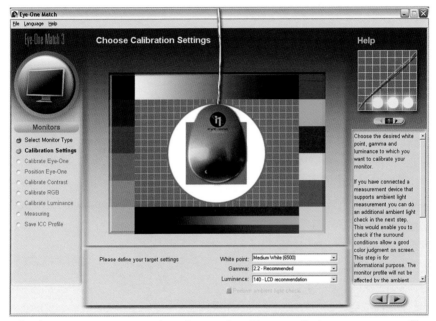

A hardware sensor measures the colors rendered by your display to create a profile

The wizard for the sensor 3⁄4 also fairly easy to use, often one or two steps after the initial installation, so it can be easily run once a month.

If you have an LCD (or flat panel) monitor, you will need to use a sensor for accurate calibration.

Some options for monitor sensors are:

■ Eye-One Display 2 from GretagMacBeth (www.i1color.com)

■ Monaco OPTIXXR from Monaco/X-Rite (www.xritephoto.com)

■ Color Vision Spyder2™ (www.colorvision.com).

All of these products work well. They all provide a software utility that uses a step-by-step wizard to guide you through the process of profiling your monitor.

These all also have an easy or automatic mode; this mode will automatically set the White Point and Gamma values for you (to 6500K and 2.2, respectively). The more advanced modes also include steps for precisely calibrating your monitor using the sensor device.

Checking the Profile

Once you have profiled your monitor, it is best to check the profile using a good visual target. On the web site, I provide some links to some good targets. Getty Images provides an excellent test image for evaluating the color of your monitor. Use Google "site:gettyimages.com color resources" to find it. A good test image contains a variety of common color and gray objects, a color test target and importantly some examples of skin tones. Open the image on your computer screen and evaluate if it appears good.

You should also try and print out a test target to compare it to the monitor. Use the steps in Chapter 4, Printing, to obtain a good print. Once the monitor is calibrated and you print properly, these two should match.

Next Steps

Now that you have read through this book, I'd like to include some notes for how you might proceed with Photoshop and image editing. Don't expect this all to be easy in the first few days. Experiment with the tasks that I have laid out. Some of my examples have been created to teach specific ideas, and as you try them out you should become more comfortable with the various element in Photoshop.

Stick with a workflow. The workflow helps keep track of all the tasks for image editing and the various tools that you might use to complete these tasks. The workflow should both provide some structure to your image editing and also make Photoshop a bit easier to learn.

I would also like to recommend some additional books that I have found useful:

Martin Evening: *Adobe Photoshop CS2 for Photographers* is a comprehensive reference to all of the Photoshop tools used by photographers. Evening covers additional image editing options and tools that you can include in your workflow.

Andrew Rodney: *Color Management for Photographers* addresses the difficult subject of color management in a way that can help you get real work accomplished. It explains how to work with Color Management with step-by-step instructions so you can get on with creating and printing successful images.

Katrin Eismann: *Photoshop Restoration & Retouching* provides an excellent set of useful tasks for image editing. It focuses on the types of goals that photographers want to achieve rather than the features of Photoshop. I also recommend Katrin's other books on digital imaging.

Index

Outline of the Image Editing Workflow

Capture the Image

- Capture good, well-exposed images

Organize the Images

- Use folders for

Open Image Files (Process RAW Files)

- Open and process image files as necessary

Image Clean-Up

- Straighten and crop

- Spot

- Reduce noise

Perform Global Adjustments

- Black and white points

- Brightness

- Contrast

- Shadows/highlights

- Color balance

- Color edits

Perform Local Adjustments: For each Local Adjustment

- Determine the local adjustment

- Make a basic selection

- Edit the selection

- Create an adjustment layer

- Perform the adjustment

- Edit the resulting mask

Photographic Edits

■ Various options for applying some different effects

Print Preparation

■ Flatten the image

■ Crop and resize

■ Sharpen the image

Print

■ Use the printer driver (basic printing), print with profiles (advanced printing), or print using an online service.

Focal Press

www.focalpress.com

Join Focal Press online

As a member you will enjoy the following benefits:

- browse our full list of books available
- view sample chapters
- order securely online

Focal eNews

Register for eNews, the regular email service from Focal Press, to receive:

- advance news of our latest publications
- exclusive articles written by our authors
- related event information
- free sample chapters
- information about special offers

Go to www.focalpress.com to register and the eNews bulletin will soon be arriving on your desktop!

If you require any further information about the eNews or www.focalpress.com please contact:

USA
Tricia La Fauci
Email: t.lafauci@elsevier.com
Tel: +1 781 313 4739

Europe and rest of world
Lucy Lomas-Walker
Email: l.lomas@elsevier.com
Tel: +44 (0) 1865 314438

Catalogue

For information on all Focal Press titles, our full catalogue is available online at www.focalpress.com, alternatively you can contact us for a free printed version:

USA
Email: c.degon@elsevier.com
Tel: +1 781 313 4721

Europe and rest of world
Email: L.Kings@elsevier.com
Tel: +44 (0) 1865 314426

Potential authors

If you have an idea for a book, please get in touch:

USA
editors@focalpress.com

Europe and rest of world
ge.kennedy@elsevier.com

Also available from Focal Press…

The Focal Easy Guide to After Effects For New Users and Professionals

Curtis Sponsler

- Achieve excellent results, fast, through Curtis Sponsler's expert teaching.

- Clear and concise color coverage helps you explore the full power of the program.

- Ideal for editors who want to learn how to push their skills to a professional level with this affordable package.

If you want to become a resourceful creative artist then look no further! This quick reference to After Effects will show you how to open, install and get up-and-running to a professional level with Adobe's motion graphics and visual effects software package.

Curtis Sponsler guides you through some of the common stumbling blocks that frustrate novice and many intermediate designers. Clear and concise full color examples will help you to quickly learn the key features, interface and functional techniques used within the production workspace. By putting these key skills into practice you will discover how to build on and extrapolate concepts, enabling you to solve common production design problems straight away! You can then move on to build simple compositions and progress into the advanced feature-set of After Effects.

As you work through each section you will grasp an ever-increasing array of tools and capabilities to discover a program that will well and truly change your working life!

March 2005 • 148 × 210 mm • 450 color images • 024051968X

Also available from Focal Press...

The Focal Easy Guide to Final Cut Pro 5 For New Users and Professionals

Rick Young

■ Save time, learn all you need to know to edit professionally with FCP5 in a few hours!

■ Concise full-color coverage, written for FCP5 but relevant to all versions.

Software packages are complex. Shouldn't software books make it easier? Simplify your life with The Focal Easy Guide to Final Cut Pro 5! This short, full-color book lives up to its name by paring down the software to its essentials. It covers only the key features and essential workflow to get you up and running in no time. When time is of the essence, less is more.

With this book you can start cutting immediately, whatever you edit, whatever the format. This is an ideal introduction whether you are a professional moving over to Final Cut Pro from another package or system, a new user, or just someone who wants to get the best results from Final Cut Pro, fast!

October 2005 ● 148 × 210 mm ● 250 color illustrations ● 0240520157

Also available from Focal Press...

The Focal Easy Guide to Combustion 4 For New Users and Professionals

Gary M. Davis

Learn all you'll need to know to get up and running quickly with Autodesk's highly-affordable, powerful version 4 upgrade to Combustion. Get a jump-start learning the major features of the software without getting bogged down with unnecessary detail.

The author shares his professional insight and extensive training experience to ensure you'll get the most out of all the professional paint, animation, editing and 3D compositing tools Combustion offers. Also featured are many workflow tips which show how to tap into the full power of Combustion 4 in your effects and motion graphics work.

October 2005 ● 148 × 210 mm ● 250 color illustrations ● 0240520106